DEVOTION BY DESIGN

ITALIAN ALTARPIECES
BEFORE 1500

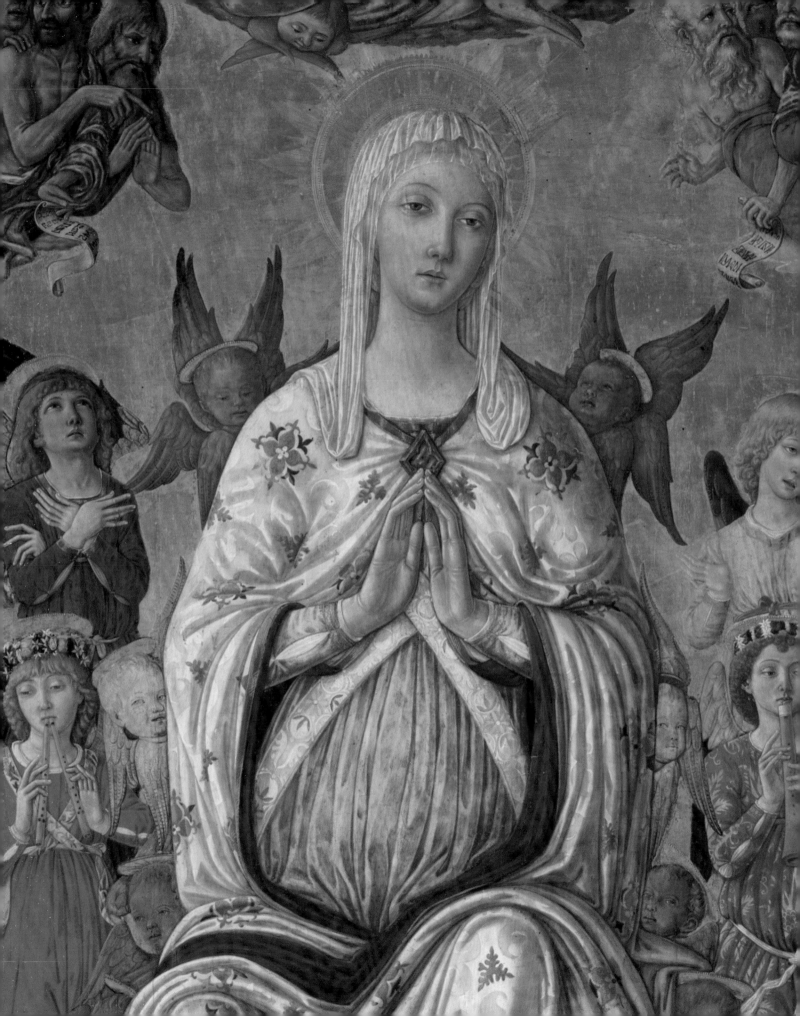

DEVOTION BY DESIGN

ITALIAN ALTARPIECES
BEFORE 1500

SCOTT NETHERSOLE

NATIONAL GALLERY COMPANY, LONDON
DISTRIBUTED BY YALE UNIVERSITY PRESS

Published to accompany the exhibition
Devotion by Design: Italian Altarpieces before 1500
The National Gallery, London, 6 July – 2 October 2011

With support from The Jerusalem Trust

Additional donations from:
José-Ramón and Mantina Lòpez-Portillo, Walter and Barbara Marais,
Mr and Mrs Richard Thornton, and The Weinstock Fund

First published in Great Britain in 2011 by
National Gallery Company Limited
St Vincent House, 30 Orange Street
London WC2H 7HH
www.nationalgallery.co.uk

ISBN: 978 1 85709 525 8
1031418

British Library Cataloguing in Publication Data
A catalogue record is available from the British Library

Library of Congress Control Number 2010937533

All measurements give height before width
All the works illustrated are from the National Gallery, London, unless otherwise indicated

Publishing Director	Louise Rice
Publishing Manager	Sara Purdy
Project Editor	Giselle Sonnenschein
Editor	Johanna Stephenson
Design	Bianca Ng
Picture Research	Suzanne Bosman
Production	Jane Hyne and Penny Le Tissier

Printed and bound in Spain by Grafos

Cover: Benozzo Gozzoli, *The Virgin and Child enthroned among Angels and Saints*, 1461–2, detail
Frontispiece: Matteo di Giovanni, *The Assumption of the Virgin*, probably 1474, detail
Page 6: Zanobi Strozzi, *The Annunciation*, about 1440–5, detail
Page 124: Marco Zoppo, *A Bishop Saint, perhaps Saint Augustine*, probably about 1468, detail

CONTENTS

DIRECTOR'S FOREWORD

Twenty years have passed since a leading connoisseur and museum director disdainfully characterised a colleague in the field of medieval Italian painting as a 'garrulous old carpenter', on account of his preoccupation with the construction of panels and frames in altarpieces. Today it is generally agreed that the understanding of an artist's work is incomplete without a sound knowledge of materials and techniques. The National Gallery's Scientific Department works closely with conservators and curators to promote such an understanding. And the connoisseur of today is more likely to turn things over and wonder how they were made – and how they were very often remade.

Now that so much art historical research is directed towards the nature of galleries and museums, we are bound to investigate ways in which art made for religious purposes centuries before was adapted to suit these institutions – a process which obscured the fact that much of it was designed for family burial chapels which had been endowed to secure some privilege in the life to come. For this reason, curators at the National Gallery have been concerned to explore such topics as the intercession of saints and the prestige of relics, as well as examining battens and nails. Both interests are reflected in the publication *Giotto to Dürer* (1991) and its sequel, *Dürer to Veronese* (1999). The present publication by Scott Nethersole, and of course the exhibition which it accompanies, revive and extend this major strand of the National Gallery's research.

NICHOLAS PENNY
Director
The National Gallery, London

INTRODUCTION

This book considers Italian altarpieces in the collection of the National Gallery and their role in the lives of people living in the Italian Peninsula between the mid-thirteenth century and the year 1500. The English word 'altarpiece' links the object to the altar; it is defined in terms of its function. This is not the case in Italian. The phrase *pala d'altare* is now generally used to specify a type of altarpiece, thus classifying the object in terms of its typology and form, rather than function. To complicate the matter further, these words and their associated meanings would have been foreign (and not only in a literal sense) to contemporary Italians. By the thirteenth century a bewildering number of terms for altarpieces was already in use. In Renaissance Venice the words *pala* (or *palla*) and *ancona* were used interchangeably to designate an altarpiece of no particular type. Elsewhere, the word *tavola* ('panel') to indicate its support is encountered in documents to designate an altarpiece, rendering it difficult to differentiate from other categories of painting.

At a slightly earlier date it might even be described as *ymago*, referring to the image alone, but neither to the function nor the support. These various terms to describe altarpieces give an indication of the variety of functions and types embraced by this category, as will be considered in the pages of this book.[1]

Any discussion of religious art of this period necessarily involves the use of terminology which may be unfamiliar. Where possible, liturgical and technical terms are explained in the text; others are given in the glossary on page 125.

The examples explored in the following pages have been drawn in large part from the collection of the National Gallery in London, and therefore reflect the collecting history of that institution. Few of them are in original or near-original condition, which is in itself significant in the 'biography' of these objects. While the many fragments on the walls of the Gallery were collected and arranged to illustrate a narrative of stylistic progress, *Devotion by Design* tells a very different story.

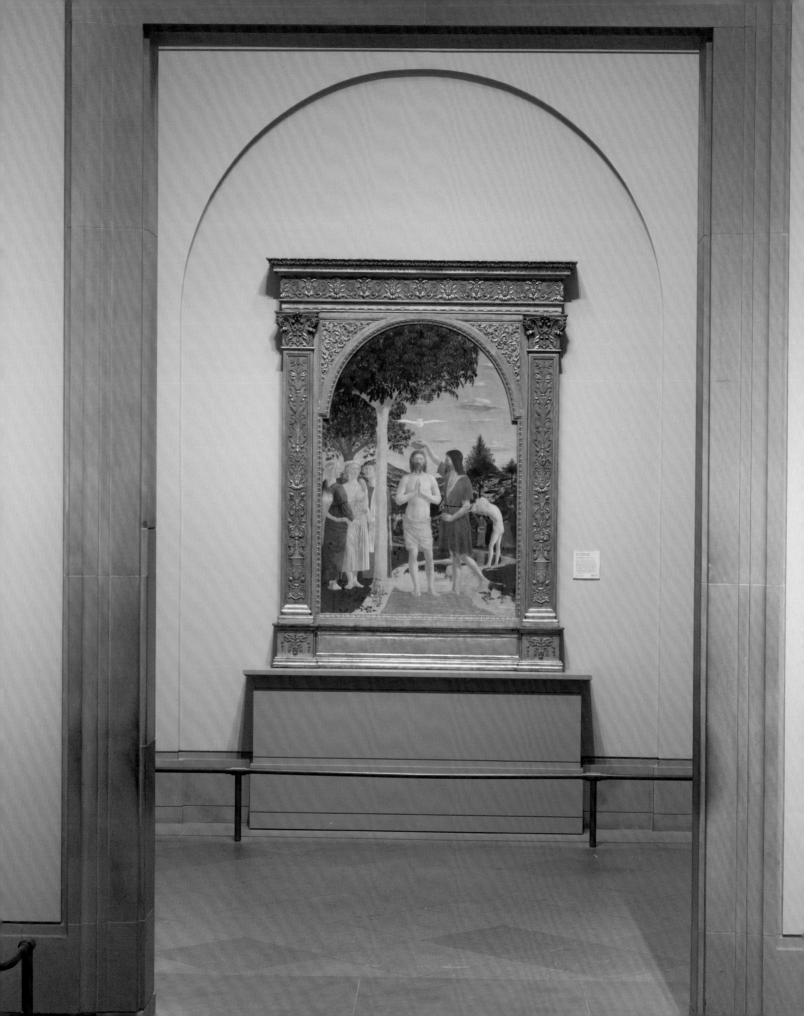

ALTARPIECES
IN CONTEXT

1 View of Piero della Francesca, *The Baptism of Christ*, 1450s, *in situ* in the Sainsbury Wing of the National Gallery, London

In 1991 Piero della Francesca's *Baptism of Christ* (fig. 1) was installed in the new Sainsbury Wing of the National Gallery. Encased in an ornate nineteenth-century tabernacle frame decorated with pilasters and motifs inspired by classicising Venetian door cases of the late fifteenth century, Piero's painting dominates the small, chapel-like room in which it hangs. The architect, Robert Venturi of Venturi, Rauch and Scott Brown, said of the specially designed gallery, with its simple plaster walls articulated with grey *pietra serena* sandstone and antique-inspired mouldings derived from Florentine architecture, 'We feel that the gallery setting should not replicate chapels or palace rooms, but should recall instead the substantial architectural character and the air of permanence of these places.'[2]

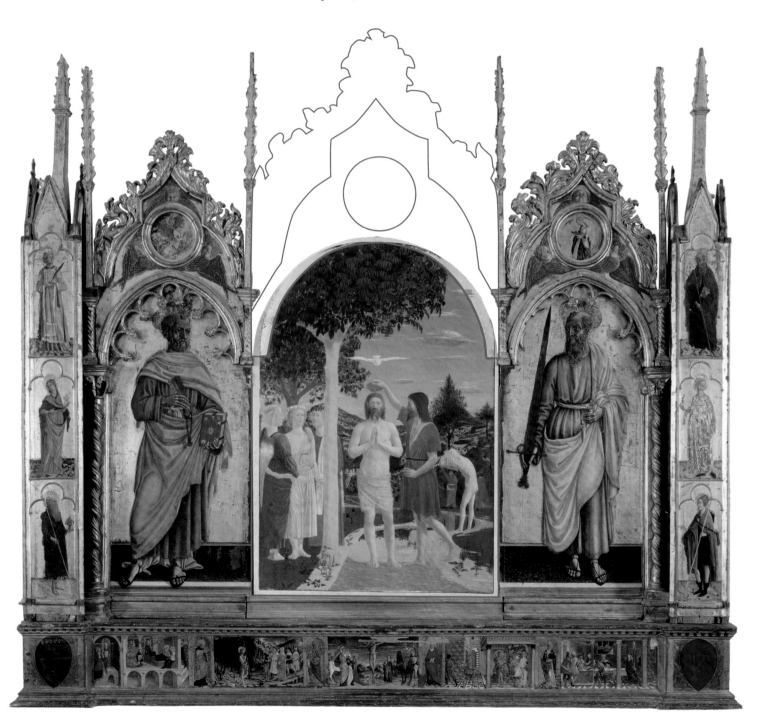

2 Photomontage of *The Baptism of Christ* as it might have appeared in the fifteenth century

Reconstruction after Andrea De Marchi, showing Piero della Francesca's *Baptism of Christ* together with elements by Matteo di Giovanni (Pinacoteca Comunale, Sansepolcro).

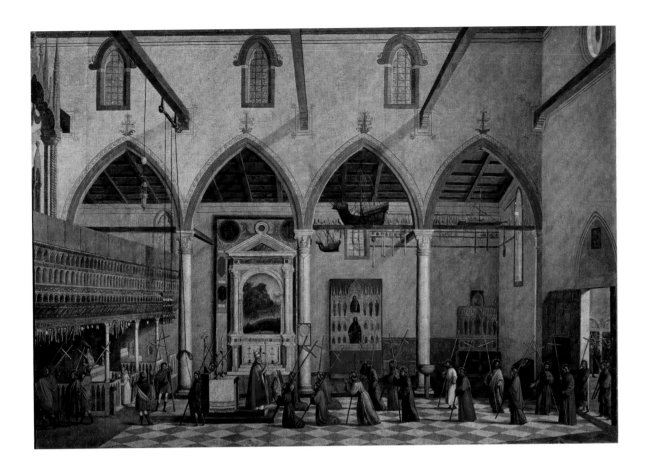

3 Vittore Carpaccio,
*Apparition of the Crucifix in
the Church of Sant' Antonio
di Castello*
Oil on panel, 121 x 174 cm
Gallerie dell'Accademia,
Venice

But the current display of *The Baptism of Christ* gives very little sense of how it would have appeared when it was positioned above the high altar of San Giovanni Battista in Borgo San Sepolcro, south-east of Florence, where it formed part of a polyptych (an altarpiece with multiple panels). The carpentry of this elaborate work was ordered from the local woodworker Benedetto di Antonio Mattei on 21 December 1433; the lateral saints, predella (base) and framing elements were painted by his compatriot Matteo di Giovanni, probably in the early 1460s, a decade or so after Piero had completed the central panel (fig. 2).[3] What is now seen as a quintessentially 'Renaissance' single-field altarpiece, or *pala*, with figures set in a spatially unified landscape, was previously part of a multi-panelled polyptych surrounded by ornate Gothic ornament. Cut out of this elaborate framework for sale in the nineteenth century, Piero's painting has become an iconic monument in a stylistic trajectory that is somewhat misleading given its previous function and context.

Unlike museums, churches did not present an ordered chronological history of altarpiece design, nor were they static places. Vittore Carpaccio's *Apparition of the Crucifix in the Church of Sant' Antonio di Castello* (fig. 3) is probably a

fairly accurate representation of the interior of Sant'Antonio di Castello in Venice in the early years of the sixteenth century. A visitor walking up the south aisle of the church of the Augustinian canons would have encountered two multi-tiered polyptychs in Gothic frames and then a large *pala all'antica* (inspired by the antique), complete with a triangular pediment above it (fig. 4). The two polyptychs in Carpaccio's painting no longer exist, having themselves been replaced with *pale*, but a single-field narrative altarpiece does survive as Carpaccio's own *Martyrdom of the Ten Thousand Christians on Mount Ararat* (Gallerie dell'Accademia, Venice).[4]

Carpaccio depicted the interior of Sant'Antonio as a space cluttered with altarpieces of different periods and types, with votive offerings hanging from the beams and the rood screen separating the choir enclosure from the main body of the church. Then as now, churches were filled with altarpieces of diverse periods, artistic styles and types; pictures over high altars or high up on rood screens might find themselves moved to side altars, sacristies or elsewhere over time. Niccolò di Pietro Gerini's much-altered *Baptism Altarpiece* (fig. 79, page 105), for example, was commissioned in 1387 for the Stoldi Chapel in the infirmary of the Camaldolese monastery of Santa Maria degli Angeli, Florence. At some point between 1414 and 1580 it was probably moved to another Camaldolese house, San Giovanni Decollato del Sasso in the Casentino near Arezzo, some distance from Florence. Consequently, an altarpiece intended for an infirmary may subsequently have furnished a high altar instead. Such changes of location often had an impact on the function of the work and necessitated radical structural modifications.

Carpaccio's *Apparition of the Crucifix in the Church of Sant' Antonio di Castello* is often used to illustrate what altarpieces looked like *in situ* or how the interior of a church once appeared. But this painting is more than simply a 'document', for it was in all likelihood itself an altarpiece intended for the very church it depicts. It shows the vision of the prior, Francesco Antonio Ottobon, at the time of the plague of 1511, in which he saw ten thousand martyrs entering the church to be blessed by Saint Peter. They appear before the saint at a temporary altar in front of the rood screen and beside Carpaccio's altarpiece of their martyrdom, here anachronistically included at the moment of the vision. Indeed, Carpaccio's *Martyrdom* altarpiece was commissioned in fulfilment of a vow made by the Prior after the monastery was spared from the plague; its inclusion here is a telling reminder not to interpret the image too literally. However art historians might study this altarpiece now, it should be remembered that it was no doubt commissioned as an act of devotion.

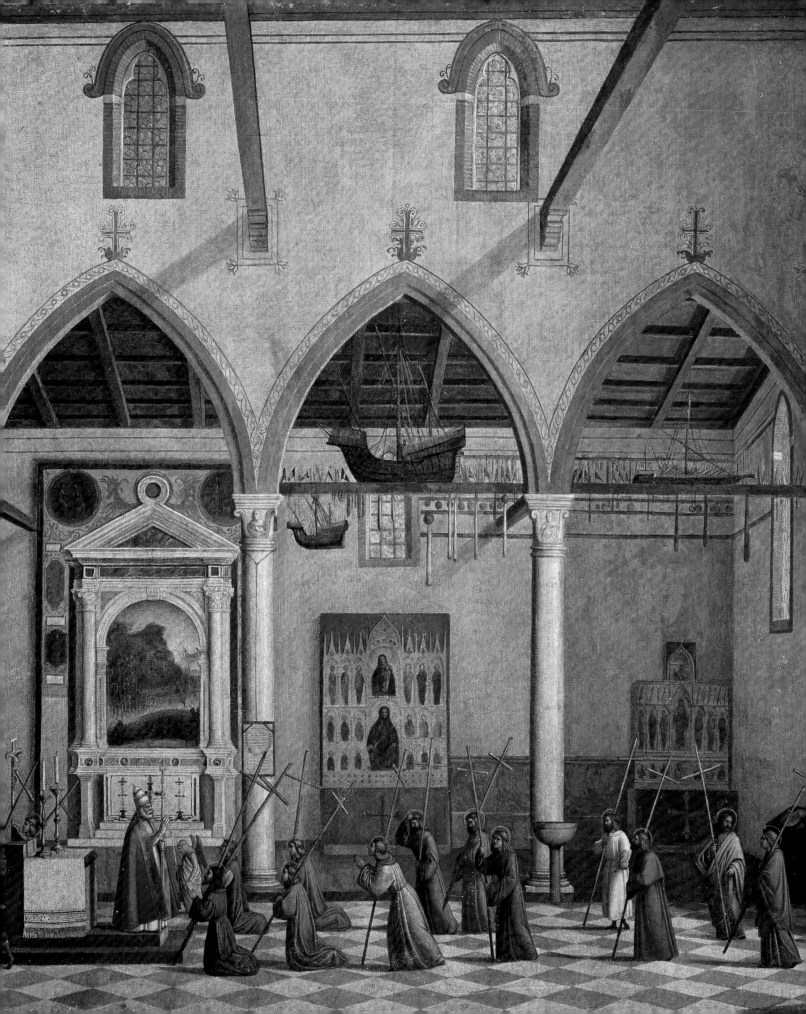

DEFINING FUNCTION

As its name suggests, an altarpiece required an altar, but an altar did not require an altarpiece. In other words, an altarpiece is defined by its proximity to the altar, whether on, above or behind the table. But the altarpiece was just one part of the ensemble of decorated objects that furnished the altar and the space around it, many of which served the liturgy (the rites prescribed for Christian public worship).[5]

The liturgy in the Middle Ages varied from region to region and changed over time. A degree of liturgical conformity was only achieved following the edicts of the Council of Trent (1545–63), the general council of the Catholic Church convened in response to the Protestant Reformation.[6] Furthermore, while the Eucharist was the most important ritual celebrated at the altar, it was not the only one.

6 Andrea di Bonaiuto da Firenze, *The Virgin and Child with Ten Saints*, about 1365–70

The order of the saints in this small picture reflects the dedications of the major chapels behind the choir screen of the Dominican Church of Santa Maria Novella, Florence. They flank the Virgin, to whom the high altar was dedicated.

THE ALTAR AND ITS FURNISHINGS

According to canon law (the Church's internal regulations that govern its organisation and members), the table at which the Mass was celebrated should be of unbroken, monolithic stone.[7] The word 'altar' probably derives from the Latin *adolere*, meaning 'to burn', perhaps in reference to pagan practice of burning sacrifices, and subsequently became associated with the surface upon which sacrifices were offered. The Christian altar originated as a symbol of the table of the Last Supper and came to be used for the celebration of the Eucharist, a ritualised commemoration of Christ's sacrifice.[8] Each church had to have a fixed high altar, but often included other altars in a variety of different locations. They might be sited in chapels, against columns or screens in churches, or equally in municipal buildings, private palaces, or even out of doors.

Altars were consecrated, that is made sacred, and were meant to contain a relic. However, this was not always possible or practical, particularly with the multiplication of altars at the end of the Middle Ages as the new mendicant orders expanded and began to build large new churches to accommodate their growing congregations. In the early thirteenth century Pope Innocent III stipulated the procedure for consecrating an altar: 'First one lays the *tabula* [or slab] down [over the relics], then one anoints the *mensa* [the table], one burns the incense and drapes the altar with cloths, finally celebrating the sacrifice.'[9] It is only at the end of the thirteenth century that any evidence survives for the consecration of an altarpiece (and presumably an altar frontal, which sits below and in front of the altar). This appears in the Roman Pontifical (the book of instructions for the rites or rituals performed by bishops) compiled shortly before the death of Guillaume Durand, Bishop of Mende, which reads:

On the consecration of a panel placed before and behind the altar.

1. The panel which is placed behind or before the altar is consecrated in the following fashion: *Our help is in the name of the Lord. The Lord be with you. Let us pray.* The prayer: *God, Thou art the source of all holiness and blessing, we pray thee in thy infinite might that over this panel of thy holy altar, which hath been made whole by thy believers' zeal and cleansed of all uncleanness, through the service of our office thou pourest forth an abundance of thy mercy and holiness. Praise be to God.*

2. At the end it is sprinkled with holy water.[10]

An altar required a *titulus* or dedication, and while all altars are notionally dedicated to God, some were also consecrated in memory or honour of one or several saints (fig. 6), a mystery (such as the Holy Trinity) or a holy object. This dedication could be communicated by means of an image, a text on the altar itself, or an inscription elsewhere in the chapel.[11] The Bardi Chapel in Santa Maria Novella in Florence, for instance, bears an inscription: 'This chapel erected in honour of God and of Saint Gregory …'. [12]

The altar inscription did not always mention the *titulus*. For example, the high altar of San Francesco in the town of Borgo San Sepolcro is inscribed: 'In the year of our Lord 1304 on the Feast of All Saints, Saint Ranieri migrated to the Lord. In that year the Commune of Borgo commissioned this altar to the honour of God and the magnificence of the saint. Amen.'[13] But the locally venerated Ranieri Rasini, a Franciscan lay brother, enshrined in the crypt beneath the altar, was not actually a saint, despite being the object of an intense local cult, nor was he, in fact, beatified until 1802.[14] The altar could not therefore have been dedicated to him, although the inscription might reflect the hopes of the inhabitants of Borgo that he soon be canonised. The *titulus* of this altar remains unknown, but it seems likely that an image of the dedicatee was included in Sassetta's *San Sepolcro Altarpiece* above it (fig. 46, page 68), among the multitude of figures represented on both sides of the altarpiece alongside Ranieri. A logical candidate would be Saint Francis, the patron of the order to which the church belonged, although he appeared on the reverse rather than the front.[15] That said, although the *titulus* of the high altar was usually the same as that of the church itself, this was not a statutory requirement. Moreover, it was not compulsory for the high altar to be dedicated to the patron of the order to whom the church belonged or to the relic it housed.

7 Benozzo Gozzoli, *Frescoes in the Chapel of San Gerolamo with Trompe L'oeil Polyptych*
Fresco
Montefalco, Church of San Francesco

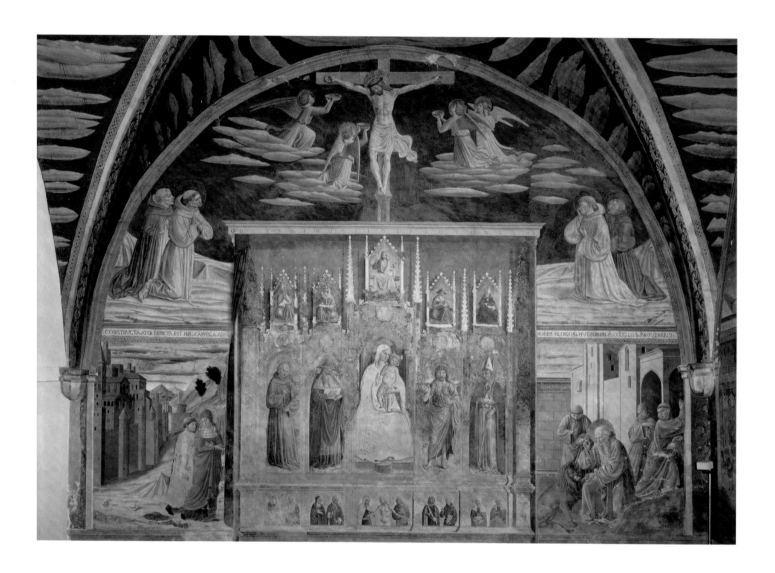

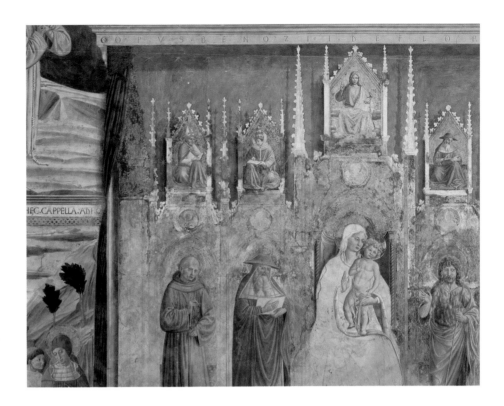

8 Detail of fig. 7 showing a fictive curtain probably used for concealing and protecting altarpieces

A whole variety of objects were associated with the altar, including sacred books and instruments such as a pyx (a receptacle for carrying the consecrated host), a chalice (a standing cup for sacramental wine) and a paten (a small plate used to hold the Eucharistic bread to be consecrated). An altarpiece, however, was not prescribed by canon law.[16] Indeed, the comparatively late arrival of the altarpiece in churches in Rome is evidence enough that its adoption was localised and not centrally mandated: as the seat of the Papacy (except during the period 1309–78, when the popes were resident at Avignon), Rome was unlikely to be slow in enforcing new ecclesiastical legislation in its churches. All that was stipulated by canon law was that the altar be furnished with a crucifix and two candles, the latter facilitating the easy reading of the missal, the book containing the prayers and responses used during the celebration of the Eucharist.[17] These regulations entered ecclesiastical law with the Fourth Lateran Council, the gathering of Catholic bishops, patriarchs, abbots and priors called by Pope Innocent III in 1215, although they might already have been in general practice.

The burning of candles was both a practical necessity and an expression of pious devotion, as in the case of the candles, paid for by the Commune, that were kept burning before the front and back of Duccio's double-sided *Maestà* (fig. 27, page 46) in Siena Cathedral. A document of 1339 records payments for:

wax candles to be kept and to be burnt on the altar of the Virgin glorious mother … out of reverence for the aforementioned Virgin Mary and for the greater honesty of devout people who pray at the back of the said [altar] in the presence of the figure of the aforementioned glorious Virgin and the saints depicted at the said side of the above mentioned altarpiece.[18]

Candles occasionally left traces on the altarpieces situated behind them, such as the (now restored) burn mark on Francesco Botticini's *The Assumption of the Virgin* (fig. 14, page 30)or the small, splatter-like losses probably created by wax in the *Nativity* panel of the predella of Carlo Crivelli's altarpiece *La Madonna della Rondine (The Madonna of the Swallow)* (fig. 56, page 83).

An inventory of 1589/90 records the contents of the meeting rooms at San Marco, Florence, of the Confraternity of the Purification and of Saint Zenobius, including more apparatus associated with the altar. As to be expected, the inventory lists a small gilded crucifix for the altar of Saint Cosmas and Saint Damian, and a larger one placed above the main altar. In addition, it also enumerates reliquaries, missals, paxes (flat tablets adorned with a sacred image that worshippers kissed as a sign of peace at a certain point in the service), chalices, altar frontals and a 'wooden ciborium' containing the pontifical glove of Saint Antoninus.[19] Similarly, Giuliano degli Scarsi commissioned a variety of liturgical objects for his family burial chapel in Santa Maria del Carmine, Pisa, including an altar with a consecrated stone, a painted curtain, a wooden step, iron torch-holders, seats, a wooden *coperchio* (possibly a kind of architectural tabernacle covering for the altar) and a painted altar frontal, as well as the now sadly fragmented altarpiece by Masaccio (fig. 68, page 95).[20]

At an early date, perhaps before altarpieces became customary, altars were occasionally adorned with polychrome wooden sculptures of the Virgin and Child, some of which still survive, particularly in central Italy. Some of these additional objects and structures are represented in Benozzo Gozzoli's *trompe l'oeil* fresco of an altarpiece (fig. 7) in the church of San Francesco, Montefalco, including a curtain (fig. 8). It is known from documents that curtains were hung before many works, including three in the National Gallery Collection: the *San Benedetto Altarpiece* (fig. 9), the *San Pier Maggiore Altarpiece* (fig. 29, page 48) and the *Pistoia Santa Trinità Altarpiece (Trinity Altarpiece)* (fig. 75, page 102).[21] These provided practical protection from dust and fading, but possibly also served an important liturgical and symbolic function, during prescribed periods such as Holy Week, before Easter, for the picture to be revealed during the singing of the celebratory 'Gloria' during the Mass on Holy Saturday.[22]

9 Lorenzo Monaco, *San Benedetto Altarpiece*, 1407–9

The frame shown here is modern; so, too, are the painted strips which separate the three panels.

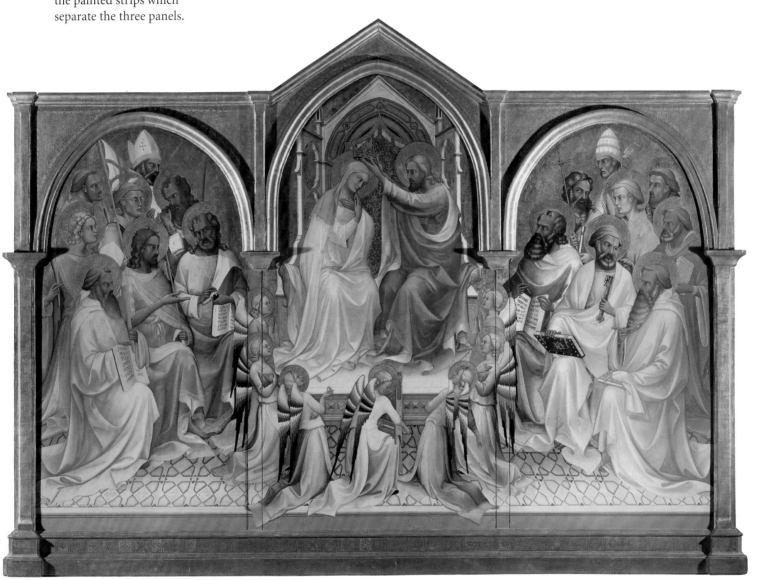

10 Detail showing Saint
 Peter's collar inscription
 in Benozzo Gozzoli's
 *The Virgin and Child
 enthroned among Angels
 and Saints*

LITURGY AND THE ALTARPIECE

An altarpiece was not an essential requirement for an altar. It was not obligatory
for the celebration of the Mass or any other liturgical ceremony.[23] This is
confirmed by images, often parts of altarpieces themselves, depicting the
celebration of the Eucharist at an altar without an altarpiece, such as the Master
of the Osservanza's painting of *Saint Anthony at Mass* (Gemäldegalerie, Berlin).
Nevertheless, much art historical scholarship has focused on the sacramental,
Eucharistic and broadly liturgical function of symbolism within altarpieces.
The cloth behind Saint Jerome in Crivelli's *The Madonna of the Swallow* (fig. 56,
page 83), for example, is richly symbolic: its pattern of great rosettes (the rose
is particularly associated with the Virgin, the 'rose without thorns') with, at the

centre of the pattern, bunches of grapes (symbols of the Eucharistic wine and, by extension, of the blood of Christ) allude at once to the incarnation of Christ in the womb of the Virgin Mary and his eventual sacrifice for mankind on the Cross.[24] In Benozzo Gozzoli's *The Virgin and Child enthroned among Angels and Saints* (fig. 58, page 86) Saint Peter's collar is inscribed with the words from Saint Matthew's Gospel, 'thou art Peter; and upon this … [rock I will build my church…]' (fig. 10), which were used in the Mass in commemoration of Saint Peter and regarded as the prototype of the sacrament of Holy Orders.

Some scholars have plausibly proposed that the altarpiece became popular when the doctrine of transubstantiation (which states that bread and wine at the Eucharist are actually transformed into Christ's body and blood) was accepted by the Fourth Lateran Council – the same Council that legislated for the presence of candles and a crucifix on the altar. The doctrine undoubtedly increased the spiritual significance of the altar, and Eucharistic references in altarpieces are frequent. In the following century several reported miracles gave visual credence to the new dogma. However, the transubstantiation of the bread and wine remained (and is still) a difficult idea to comprehend, not least because a change in substance, but not species, meant that there was no visual basis for belief. Faith was thus necessarily, and not just proverbially, blind. Even the visionary writer, painter and abbess, Saint Catherine Vigri – a central figure in the reform of the Franciscan Order of Saint Clare (the Poor Clares) during the fifteenth century – confessed that she had had terrible doubts about the actual presence of the divine in the Eucharist, until Christ appeared to her and personally explained the mystery of transubstantiation.[25]

Accompanying this change in dogma was a new liturgical ritual, in which the officiating priest, standing on the same side of the altar as the congregation, consecrated the host with his back to them but lifted it high enough to be visible to the faithful (fig. 11)[26] This represented a change from the earlier Roman liturgy, in which the altar had to be accessible from both front and back, so that the subdeacon (or assistant priest) could occupy a position across from the celebrant.[27] The space behind the altar was now free to be taken up by an image, which gave meaning and structure to the ritual occurring in front of it. Thus the change in dogma and liturgy together may have created conditions appropriate for the introduction of the altarpiece. This shift may also provide an explanation for how the decidedly un-visual mystery of transubstantiation might have been given an accessible focus, in the correlation between the host at the point of elevation during the Mass and the image represented on the altarpiece behind it.

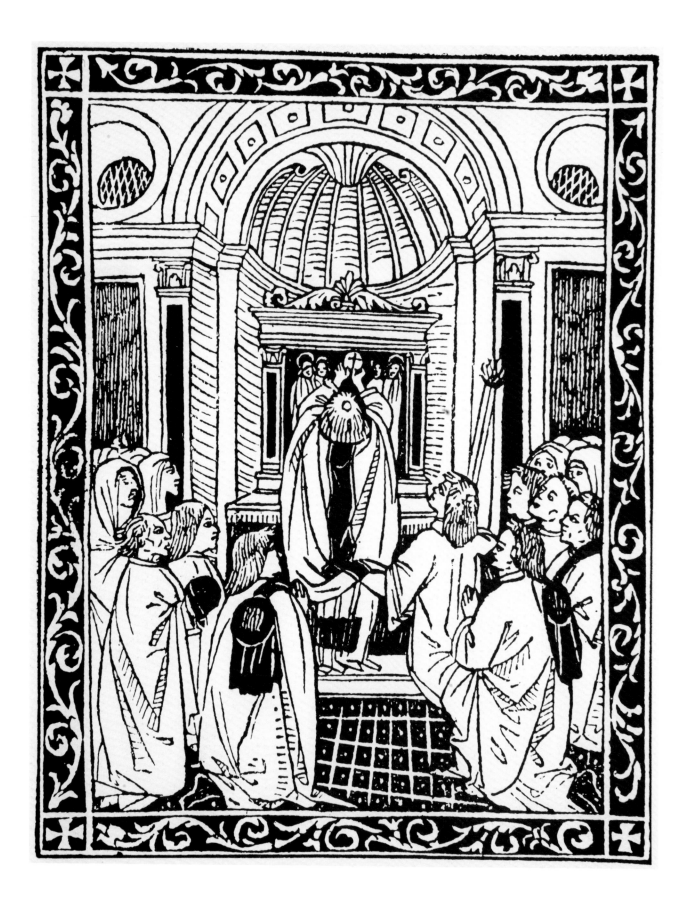

11 Anonymous Florentine, 'Elevation of the Host', from Girolamo Savonarola, *Tractato del Sacramento e dei misterii della messa*, about 1493 Woodcut

Although this account of the development of the altarpiece has been widely accepted, it can no longer be entirely sustained.[28] The Mass was regulated by a combination of canon law and local conditions, meaning that, in reality, centralised doctrine was mixed with traditional practices.[29] The Fourth Lateran Council did not provide an absolute turning point: elevation of the host during the Eucharist occurred before this date, as did celebration of the Mass facing towards the east (*versus orientem*), while celebration facing the congregation (*versus populum*) continued in the great Roman basilicas long afterwards.[30] Furthermore, references to pictures over altars occur as early as the tenth century.[31]

Despite the uncertainty surrounding their origins, by the fifteenth century altarpieces clearly provided a visual framework for the celebration of the Eucharist. The composition of Benozzo Gozzoli's *Altarpiece of the Purification* (figs 58–63, page 86), for example, makes reference to the ritual sacrifice enacted before it. At the moment when the priest elevated the consecrated host above the altar, the bread would have lined up on the vertical axis with the depiction in the predella of the infant Christ above an altar in the *Presentation in the Temple* and, above that, with the figure of Christ in the main panel of the altarpiece. The actual body of Christ transubstantiated in the bread of communion, and the represented body of Christ in the altarpiece, together with the represented and actual altars, were all in alignment.

A similar point may be made about the representation of an altar in Giovanni dal Ponte's *The Ascension of Saint John the Evangelist, with Saints* (fig. 41, page 62), in which Saint John the Evangelist raises his arms in the direction of the resurrected Christ in the centre. This vertical axis was frequently used in altarpieces for representations associated with Christ's sacrifice, such as the *Crucifixion*, the *Entombment* or the *Pietà* (fig. 12).[32] Similarly, the image of *The Man of Sorrows* (fig. 13), ultimately derived from an image of Christ that appeared to Saint Gregory at Mass and probably originally the central pinnacle of a Venetian polyptych, was no doubt included to complement the ritual of the Eucharist.

These examples emphasise how such altarpieces might have been viewed by the congregation during the celebration of the Mass, which would have given significance to the sacramental themes and made sense of the compositional structures in them. But an altarpiece might serve many other liturgical functions.

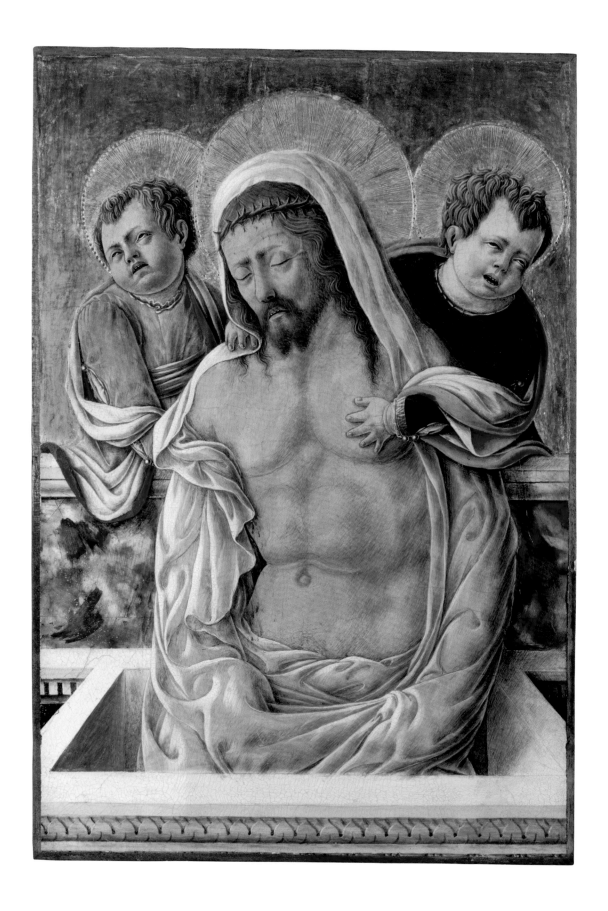

12 Giorgio Schiavone, *The Pietà* from *San Niccolò Altarpiece, Padua*, probably 1456–61

13 Attributed to Jacobello del Bonomo, *The Man of Sorrows*, about 1385–1400

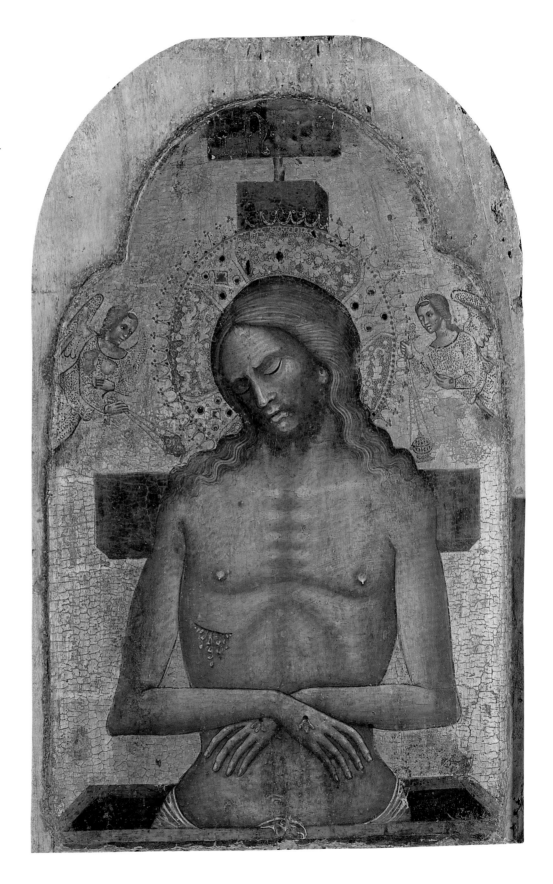

14 Francesco Botticini,
*The Assumption of the
Virgin*, probably about
1475–6

BEYOND THE EUCHARIST

In addition to the Eucharistic themes associated with the Mass, altarpieces also
represented subjects which resonated with their other functions. The statutes
of the Confraternity of the Purification in Florence reveal, for instance, that
on arriving in the oratory the young members of the Confraternity uttered
the prayer 'Lord give us peace' before advancing to the altar where they
recited an Ave Maria, a prayer for the intercession of the Virgin Mary. Upon
being admitted to the Confraternity they knelt before this altar to make their
confession, and it was here that they were dressed for the first time in their white
confraternal robes and sang hymns in praise of the Virgin.[33] Many altarpieces
feature the Virgin and Child as their central image. Their presence was surely
intended to underscore the sacrament of the Eucharist by emphasising Christ's
incarnation in his mother and, by extension, his ultimate sacrifice. The role
of the Virgin here is not solely as vessel for the Child, but also as intercessor:
sinners might pray to her to intercede on their behalf and ask her son for mercy.
Indeed, in the case of chantries (funds established to pay for Masses to be sung

for a specified purpose, often the soul of the deceased donor), the celebration of the Eucharist and the role of the Virgin and saints as intercessors were complementary, as the image of the Virgin and Child would have functioned both in relation to the Mass and as a reminder that she would petition on behalf of the donor.

But altarpieces could have had more practical functions too. The suite of three altarpieces commissioned for San Zaccharia in Venice from Giovanni d'Alemagna and Antonio Vivarini (1443) seem to have been conceived both visually and structurally as giant reliquaries, and even contain a cupboard in which relics were stored.[34] Large double-sided altarpieces sometimes served auxiliary functions as threshold barriers through which nuns in enclosed orders might follow the Mass or communicate with the outside world.[35] The intended role of an altarpiece could even be subverted to acquire additional meanings. Francesco Botticini's *The Assumption of the Virgin* (fig. 14), which is thought to illustrate the heretical writings of the humanist Matteo Palmieri, was defaced at an unknown date, presumably because of the unconventional beliefs of its donor (figs 15 and 16). Displayed in its vandalised form, it might have become the focus of an anti-Palmieri or at least anti-heretical 'campaign'. It certainly elicited a strong response, as testified by the fact that by 1657 it had been hidden behind a curtain 'for a long time', although the precise reason for this veiling remains unknown.[36] Conversely, paintings probably never intended to be displayed on an altar might acquire new significance when installed above one. Raphael's portrait of Pope Julius II, for instance, was displayed after the pontiff's death in 1513 on an altar in Santa Maria del Popolo, where it was reportedly visited by 'all of Rome'.[37]

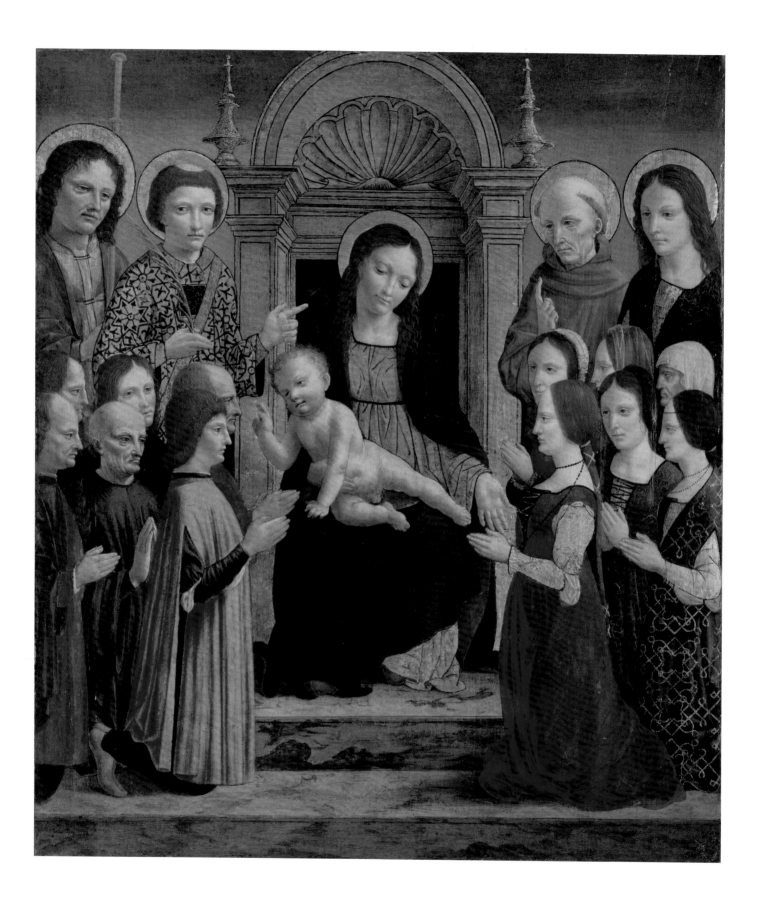

IS IT AN ALTARPIECE?

Since it cannot be reduced to a single definition, the altarpiece cannot be comprehended in terms of a single context or function.[38] Indeed, it can be argued that the very validity of the category is questionable.[39] For even if context and function could be fixed, we cannot be sure that the intentions of patrons were followed or understood by the multitude of lay and ecclesiastical spectators, devotees and liturgical celebrants who prayed before altarpieces, glanced at or simply walked past them. What is more, a substantial number of 'devotional paintings' have survived whose function or purpose remains difficult to determine.

The artist who painted *The Virgin and Child with Saints and Donors* (fig. 17), known as the Master of the Pala Sforzesca, was clearly inspired by an altarpiece. The panel echoes altarpieces such as Benozzo Gozzoli's *Altarpiece of the Purification* (figs 58–63, page 86), but at roughly half a metre square it is

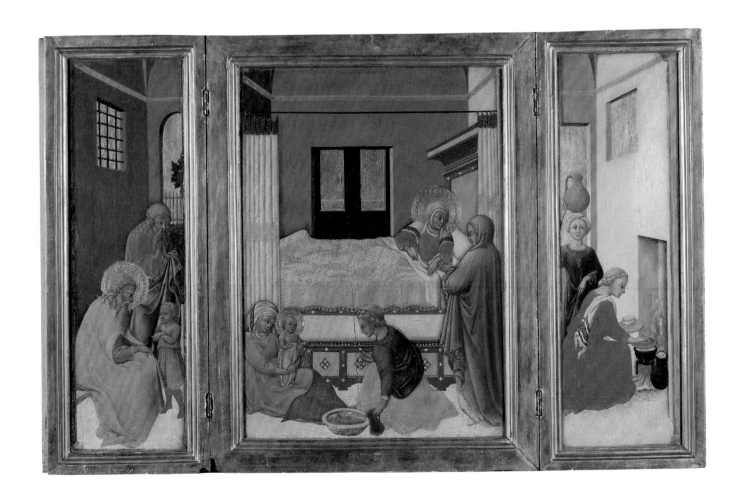

doubtful that it ever decorated an altar. It is simply too small. Similar small-scale winged panels, such as the triptych *The Birth of the Virgin* by the Master of the Osservanza (fig. 18), are often called portable altarpieces. Many pictures now described as portable altarpieces probably never adorned an altar. However, the distinction between what constituted public or private devotion is not a clear one.[40]

Without knowledge of original context is it ever possible to identify an altarpiece with certainty? Unusually, for a work of this date, Lippo di Dalmasio's *The Madonna of Humility* (fig. 19) is painted on canvas as opposed to panel, and consequently has been described as a processional banner. However, Lippo painted at least two altarpieces on linen and so his *Madonna of Humility* may similarly have adorned an altar. Andrea di Bonaiuto da Firenze's small panel showing the Virgin and Child flanked by ten saints (fig. 6, page 18) has been identified as a kind of mnemonic ground plan of the dedications of altars at Santa Maria Novella.[41] It clearly bears a close relationship to altars and, indeed, resembles an early altarpiece in reduced scale; but did it ever serve as an altarpiece itself?

Filippino Lippi's altarpiece for the Carafa Chapel in Santa Maria sopra Minerva, Rome, is a *tour de force* of pictorial illusionism: a fresco that tricks the eye into believing that the altarpiece is an object independent of the chapel that surrounds it, all the while remaining physically inseparable and materially indistinguishable from the chapel wall. A similar point could be made about Benozzo Gozzoli's frescoed altarpiece in San Francesco at Montefalco (fig. 7, page 20). Lippi's fresco might have been intended to evoke some of the first mural 'altarpieces' in Rome, such as those in Santa Balbina, or to resonate with the frescoed altarpiece by Pietro Perugino in the Sistine Chapel (painted in the early 1480s and destroyed when Michelangelo began the *Last Judgement* in 1534). However, both Lippi and Benozzo Gozzoli's frescoes may also be understood as exhortations to consider the altarpiece as part of the larger programme of the chapel decoration which covers the walls and ceiling. In so doing, they might downplay the very importance of the altarpiece as a category. Or, alternatively, they might confirm the importance of having a visual focus of devotion for the rites that were performed before the altar.

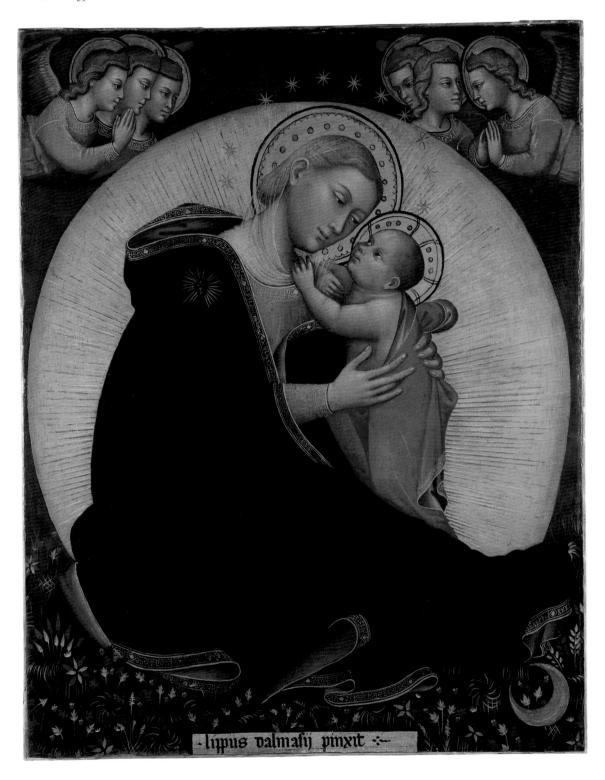

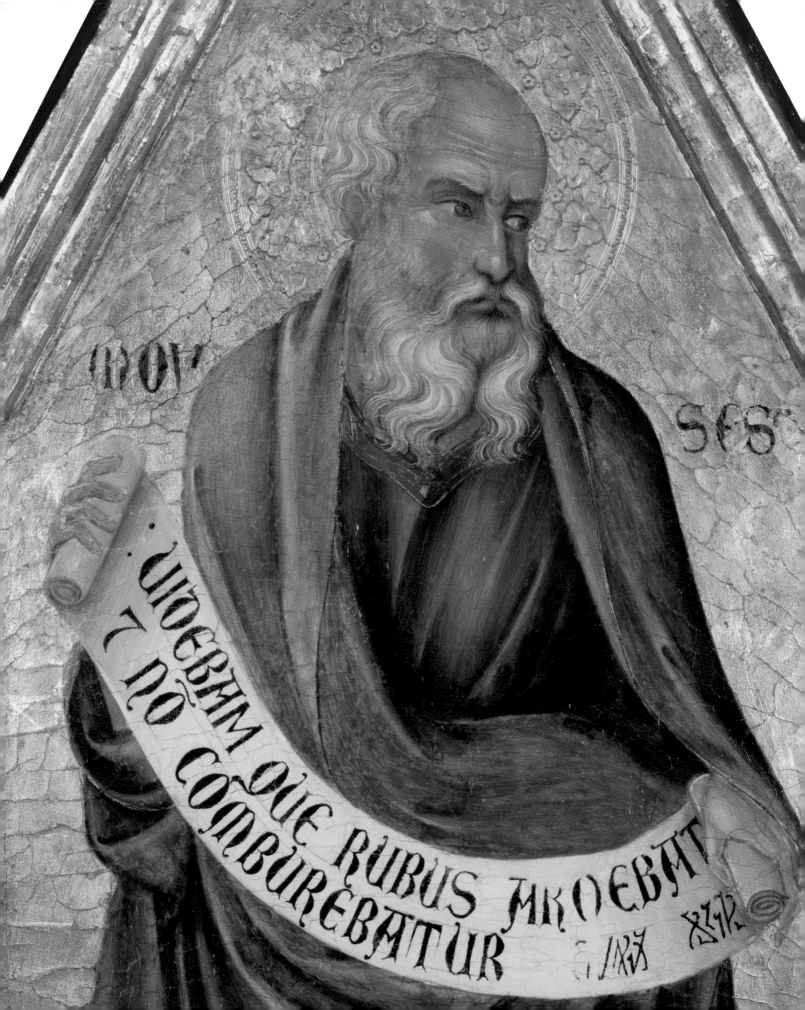

MOY SFS

VIDEBAM QUE RUBUS ARDEBAT
Z NO COMBUREBATUR

ITALIAN ALTARPIECES: STRUCTURE AND TYPE

20 Detail from Ugolino di Nerio, *Moses* from *The Santa Croce Altarpiece,* about 1325–8(?)

From the time of the first examples, which are dated to the early years of the fourteenth century, the polyptych was to become one of the most popular formats for altarpieces produced on the Italian Peninsula. As its name implies, it is defined by its multi-panelled construction. Such polyptychs were made up of several carefully arranged panels of different sizes, usually depicting individual or paired saints in the outer panels, with the Virgin and Child in the middle. The entire ensemble was set in an ornate architectural framework which often had further paintings in different registers above the main tier, and in the piers or pilasters to the sides. Occasionally the central panel might contain a narrative (fig. 21).

21 Matteo di Giovanni, *The Assumption of the Virgin*, probably 1474

This was originally the central panel of a polyptych. The flanking panels are in Italy.

22 Detail showing the *all' antica* frame of Carlo Crivelli's *The Madonna of the Swallow*

During the course of the fifteenth century the polyptych was gradually superseded as the dominant type by the *pala* (plural: *pale*) – the single-field, spatially unified altarpiece. Developed in Florence in the second quarter of the fifteenth century, the *pala* often represented the Virgin and Child flanked by saints, but it might equally have shown a narrative, arranged within a unified space. It would frequently be surrounded by an *all'antica* (classicising) frame (fig. 22), with pilasters at the sides that supported an entablature.

Whether polyptych or *pala*, an altarpiece needed a base or plinth, generally a box-like construction, sometimes strengthened by internal struts. This 'architectural' element is now known as the 'predella' – though different words were used in the period. This term has now been extended to take in the images often painted on them – sometimes more saints, frequently narrative scenes telling a complete story or relating to the images above. These might be divided by mouldings, or by painted or gilded ornamental strips.

THE POLYPTYCH

The earliest polyptychs date to shortly after the year 1300, when the type came to be promoted by Sienese artists working on commissions for Dominican and Franciscan churches (and to a slightly lesser extent, the houses of their fellow mendicants, the Augustinians).[42] The earliest examples, such as Duccio's *Polyptych No. 28* (fig. 23), had only a single tier of saints flanking the Virgin and Child. But by 1371, when Jacopo di Cione's altarpiece for San Pier Maggiore in Florence (fig. 29, page 48) was assembled on the high altar, the structure had

grown to such a degree that a block and tackle were needed to hoist it into place and the delicate framing elements – the Gothic crockets and finials – could only be attached *in situ*.

The polyptych had a long life and, although it eventually came to be succeeded by the *pala*, this change was not sudden. The most cursory glance at the oeuvre of the Folignese painter Niccolò di Liberatore, for instance, reveals that he continued to paint multi-storeyed polyptychs long into the second half of the fifteenth century, some – like the *Montelparo Polyptych* (1466) in the Pinacoteca Vaticana – with a double predella. Even a work painted in the last decade of the century, such as Leonardo's *The Virgin of the Rocks* (fig. 24), which is so often considered the apogee of 'Renaissance' design, was originally inserted into a multi-tiered, gilded construction by Giacomo del Maino, more a piece of architecture than a frame, and including more sculpture than painting.

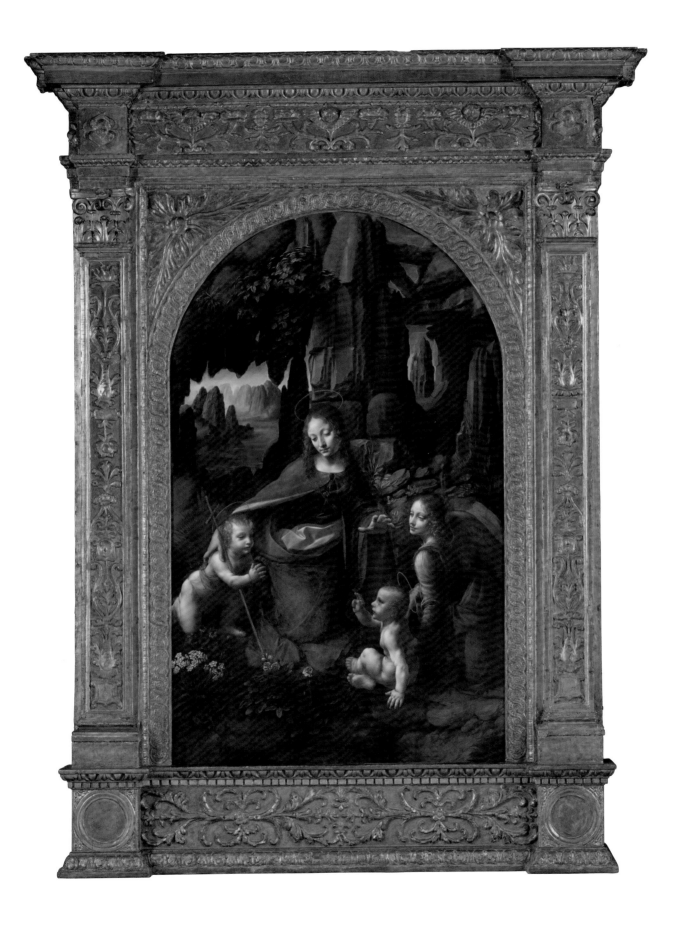

THE 'PALA'

The contract for Benozzo Gozzoli's *Altarpiece of the Purification* (figs 58–63, page 86) indicated that it was to be painted in likeness – in '*modo et forma*' – of Fra Angelico's high altarpiece for San Marco, Florence (fig. 64, page 88). This was not a rare stipulation:[43] about a decade earlier, on 1 September 1455, Neri di Bicci noted in his *Ricordanze* (book of memories) that he had been commissioned to paint a picture for the Bagnesi altar in San Remigio in '*modo et forma*' of an altarpiece then in the church of San Francesco al Monte, just beyond the walls of Florence. The model for Neri's altarpiece has been identified as *The Annunciation* signed by Zanobi Strozzi (fig. 25). Although both altarpieces depict the same subject, Neri's painting varies considerably from its prototype. Evidently the contract did not bind him to copy Zanobi's altarpiece exactly: the clause '*modo et forma*' here appears to indicate that Neri was to follow the type or form of Zanobi's work, described in the *Ricordanze* as a '*tavola d'altare quadra*', or square altar panel. Although Zanobi's altarpiece has been trimmed, sliced in half and has lost its frame, Neri's *Ricordanze* helpfully records that it was originally rectangular, styled after the antique, and that it had 'side columns, an architrave, a frieze, [and] a foliate cornice', with a predella decorated with three scenes and the patron's coat of arms.[44] In short, it was a *pala*. The type was still sufficiently novel in 1455 for Neri's patron to specify in the contract that the final work should possess these rectilinear and classicising forms.

Scholars continue to debate the *pala*'s first documented appearance from among several candidates of the same generation, paintings by Fra Angelico, Fra Filippo Lippi and Domenico Veneziano chief among them.[45] Because several of these artists were working in churches that had been built or altered by the Florentine architects Brunelleschi or Michelozzo, this more highly unified and integral conception of altar, altarpiece and surrounding architecture is sometimes attributed to them.[46] Support for this theory is found in a document of 1434 which deals with the projected side chapels for the church of San Lorenzo in Florence, then being rebuilt under the direction of Brunelleschi, as it is here that the '*tabula quadrata*', or rectangular panel, is first mentioned.[47]

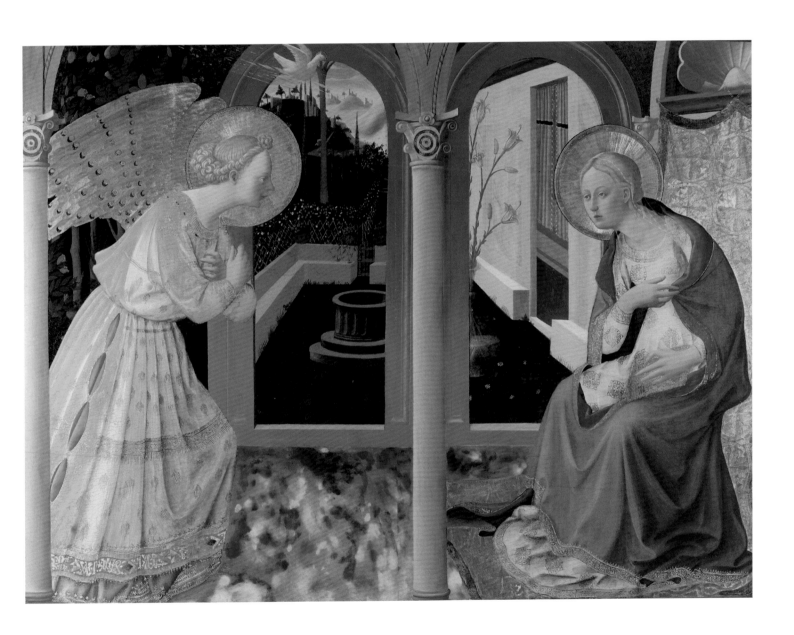

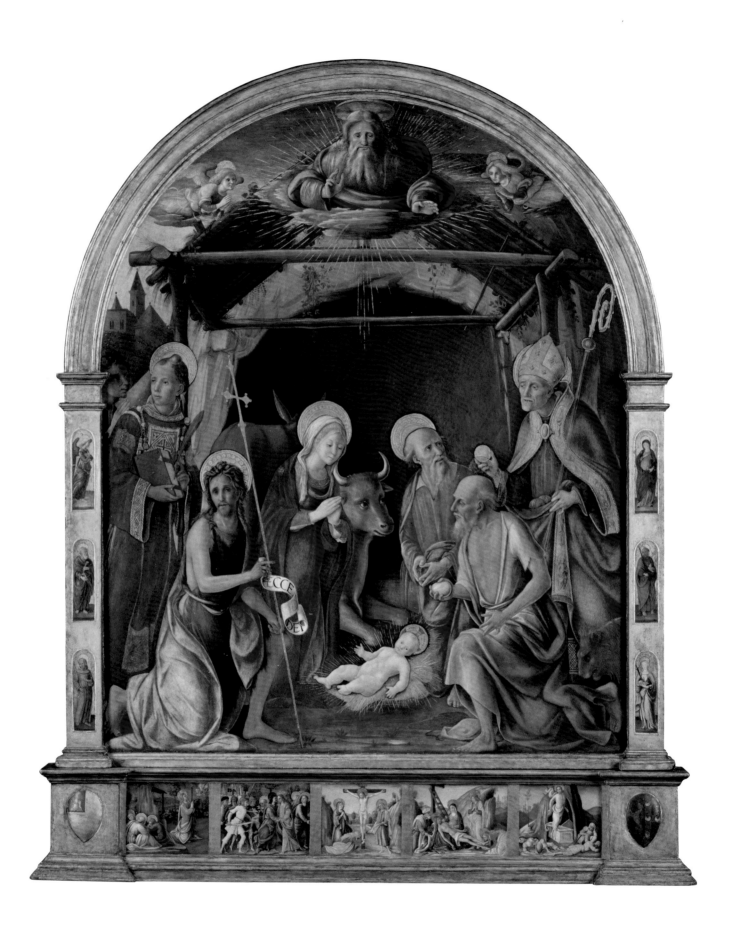

While it is true that the *pala* would eventually become more common than other types of altarpiece, its triumph was neither absolute nor instantaneous. Nor, indeed, was its design rigidly adopted: hybrids abounded. In reality, a plethora of forms was available to patrons, artists and woodworkers. The pressures of local traditions, together with practical considerations such as cost and labour or the logistics of transport from place of production to place of installation, meant that various different solutions co-existed, not only up and down the Italian Peninsula, but also simultaneously within the same church.

The speed with which the *pala* was taken up in centres outside Florence varied considerably. The type appeared fairly quickly in Perugia, probably through the mediation of Florentine artists such as Benozzo Gozzoli, and in a form that closely replicated Florentine examples (see, for example, Giovanni Boccati's *Madonna del Pergolato* of 1446, painted for the Oratory of the Confraternity of the Disciplinati di San Domenico and now in the Galleria Nazionale dell'Umbria, Perugia), even if local types, often including a niche containing a sculptured figure, also existed.[48] In contrast, in Siena and its surroundings, the polyptych remained the popular type, despite the city's close proximity to Florence. Matteo di Giovanni's *The Assumption of the Virgin* (fig. 21, page 38) originally had flanking panels painted with Saints Michael and Augustine, which still survive in Asciano.[49] Even once the Sienese had embraced the rectangular panel, in works such as Pietro Orioli's *The Nativity with Saints Altarpiece* (fig. 26), local artistic traditions continued to prevail, in this case the arched top that recalls earlier Sienese altarpieces. Venice, too, remained resistant to the *pala* until about 1470, with the creation of works such as Bellini's *Saint Catherine of Siena* (now lost).[50] Elsewhere, but especially in northern Italy, *all'antica* framing elements were used to divide a unified space into compartments, as with Mantegna's *San Zeno Altarpiece* (1457–9), Bernardino Butinone and Bernardino Zenale's polyptych at San Martino, Treviglio (1485), or Giovanni Bellini's triptych for the Frari, Venice (1488). In such works, fictive architecture and actual frame were united into creating the illusion of a single space, despite its apparent division by the frame. The same might once have been true of Cosimo Tura's *The Virgin and Child enthroned* (NG 772).

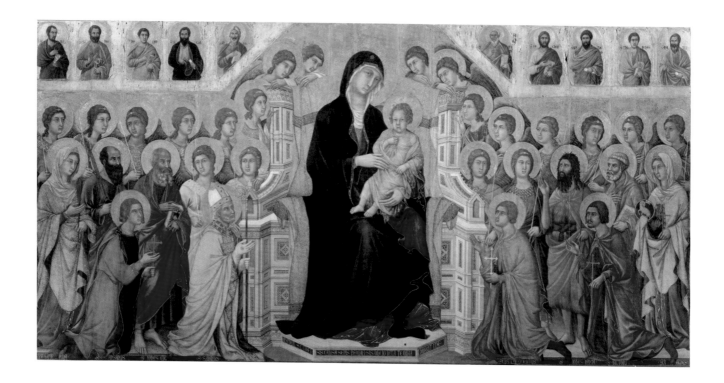

27 Duccio, *Maestà*, 1311
Tempera on poplar,
424.9 x 2118 cm
Museo dell'Opera del
Duomo, Siena

REPRESENTATIONAL HIERARCHIES

The decorative vocabulary of the *pala*, especially that of its tabernacle frame, was inspired by antiquity and contrasts considerably with the Gothic ornament typically found on the frames of polyptychs. Consequently, the typological development from polyptych to *pala* is sometimes thought to parallel a rather crudely characterised – and somewhat problematic – stylistic progression from 'Gothic' to 'Renaissance'. Quite apart from stylistic differences, the two altarpiece types are distinguished by a shift in representational hierarchies but not devotional ones, with visual strategies developed to differentiate the Virgin, Child and saints within the composition, as well as by variations in their construction.[51]

An account of the festivities that accompanied the installation of Duccio's *Maestà* (fig. 27) on the high altar of Siena Cathedral in 1311 records that speeches and prayers were offered to God and 'his mother, Madonna ever Virgin Mary, who helps, preserves and increases in peace the good state of the city of Siena and its territory, as advocate and protectress of that city, and who defends the city from all danger and all evil'.[52] The Sienese had considered the Virgin their special protectress ever since the battle of Montaperti in 1260, when they believed she had interceded on their behalf to help defeat Florentine troops.

Her honorific position is therefore indicated in the *Maestà* by her size: she is almost twice as large as the surrounding saints and angels (fig. 28). This strategy of associating importance with size was widespread and, given the Virgin's role as intercessor, was not restricted to Siena. On polyptychs in general, each saint (or pair of saints) is physically separated from every other one by mouldings. These figures inhabit their own space. They do not compete for prominence with the Virgin, whose importance was often emphasised by a larger and more prominent gable (fig. 23, page 40). This hierarchy was also applied to narrative scenes such as the Coronation of the Virgin in the main tier of the *San Pier Maggiore Altarpiece* of 1370–1 (fig. 29). Witnessing the scene are saints and angels

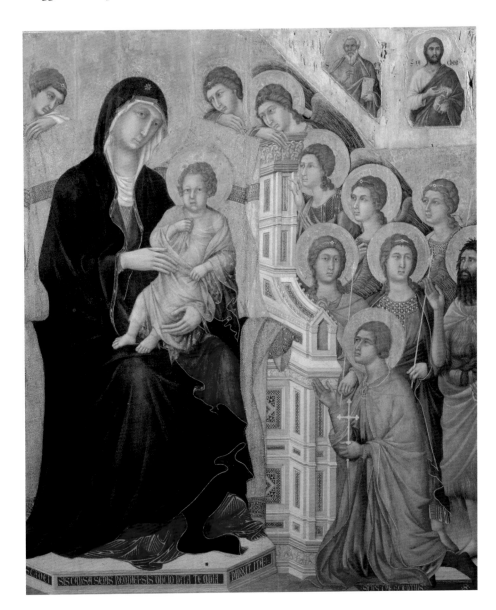

28 Detail of fig. 27

29 overleaf, left
Jacopo di Cione and workshop, *San Pier Maggiore Altarpiece*, 1370–1

30 overleaf, right
Detail of fig. 29 showing the scale of figures in the central main tier panel

31 Francesco Botticini,
San Gerolamo Altarpiece,
about 1490

who appear diminutive relative to Christ and his mother; the Virgin inclines her head to receive the crown, ensuring that she appears on a level just lower than Christ.

The association between scale and significance survived well into the fifteenth century. Francesco Botticini's *San Gerolamo Altarpiece* (fig. 31) presents a special case. The diminished scale of the so-called donor portraits relative to the surrounding saints and the augmented proportions of Saint Jerome in the central panel reflect an internal hierarchy based on size that was already somewhat old-fashioned by the 1490s. Perhaps the unusual configuration of this *pala*, with an embedded 'icon' at its centre, allowed for such a traditional treatment. More typically, the development of a unified space in *pale* saw new representational techniques for distinguishing the figures within altarpieces: the Virgin might be seated on an elaborate throne to separate her from the surrounding company, or an architectural framework, created by the frame itself or by fictive painted arches, used to isolate her. To further accentuate her prominence, the Virgin might be placed at the vanishing point of a perspectival construction, as in Fra Angelico's high altarpiece for San Marco (fig. 64, page 88) or, at least, at the apex of a triangulated composition.

A quite different technique was used by Andrea Mantegna in *The Virgin and Child with the Magdalen and Saint John the Baptist* (fig. 32), where the two flanking figures tower over the seated Virgin. This type of composition, in which a sacred company is assembled in a single space and on the same ground, is sometimes termed a '*sacra conversazione*' ('holy conversation'). However, the term is both anachronistic and incorrect, not least because, despite inhabiting a single space, Mantegna has gone to some lengths to suggest a lack of community between the figures:[53] they all look outwards in a different direction, suggesting that each has a different focus of attention. Although Saint John's cloak brushes tantalisingly close to the Virgin's shoulder, he does not acknowledge her presence. And while the Baptist and the Magdalen are of the same scale as the Virgin, the viewer is in no doubt as to her special position and role, seated as she is beneath a rich red canopy.

The shift towards a unified space in the fifteenth century has led some art historians to associate iconic and narrative modes of representation with polyptychs and *pale* respectively. With the gradual disappearance of the predella

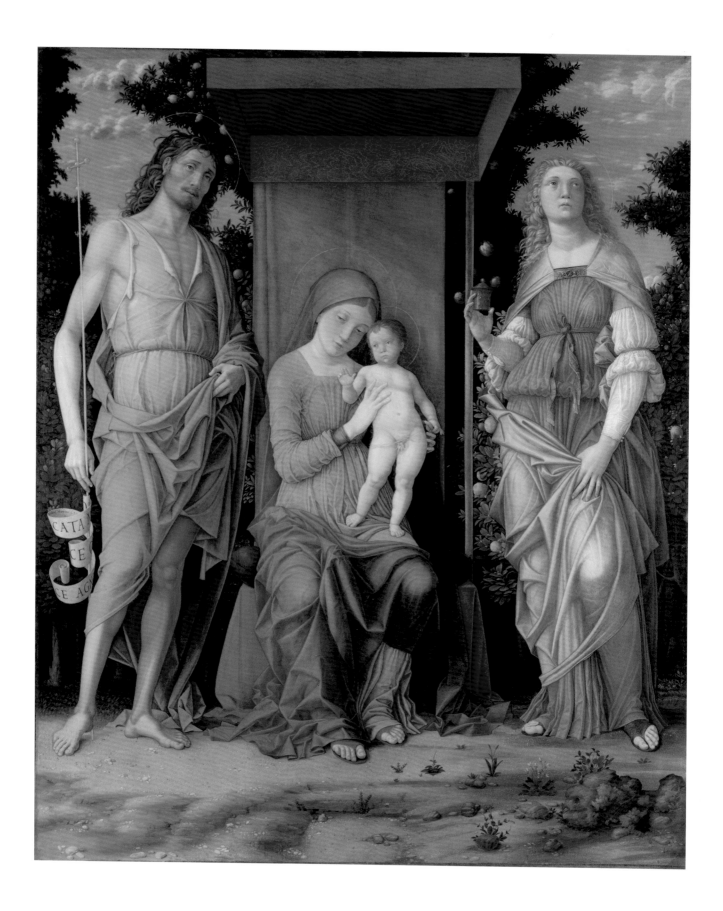

32 Andrea Mantegna,
*The Virgin and Child
with the Magdalen and
Saint John the Baptist*,
probably 1490–1505

33 Detail of fig. 35 showing
the narrative scenes of the
predella incorporated into
the main panel

from the foot of the *pala*, it has been argued that narrative elements were
moved from here up into the main panel. Altarpieces that never had a predella,
such as the Pollaiuolo brothers' *The Martyrdom of Saint Sebastian* (fig. 34),
would seem to support such a hypothesis, although others, such as the *Strozzi
Altarpiece* (fig. 35) by Lorenzo Costa and Gianfrancesco Maineri, in which the
narrative scenes of the predella have been skilfully integrated into the Virgin's
throne of the main panel (fig. 33), complicate it. This argument is further
qualified by the sheer number of surviving panels which do not fall into this
pattern, such as the series of polyptychs commissioned for Siena Cathedral
in the early decades of the fourteenth century depicting narrative subjects in
their main panels as well as in the predella. Equally, Botticini's *pala* for San
Gerolamo, Fiesole (fig. 31), innovatively combined the two modes by inserting
a narrative image of the penitential saint within the central field of a non-
narrative altarpiece.

34 Antonio del Pollaiuolo
and Piero del Pollaiuolo,
*The Martyrdom of Saint
Sebastian*, completed 1475,
shown in a nineteenth-
century frame

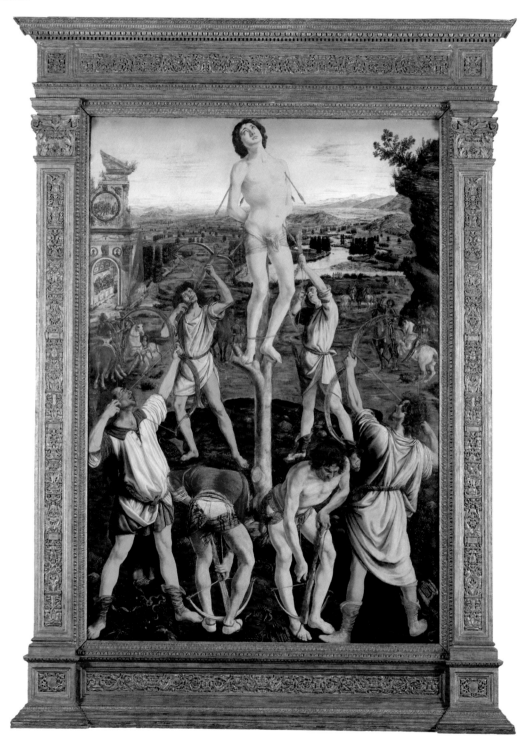

35 Lorenzo Costa and Gianfrancesco Maineri, *The Virgin and Child enthroned between a Soldier Saint, and Saint John the Baptist (Strozzi Altarpiece)*, probably 1499, shown in a nineteenth-century frame

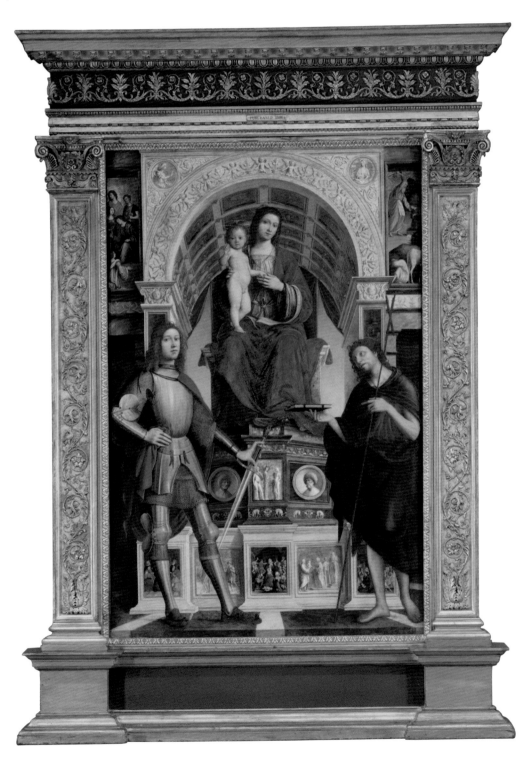

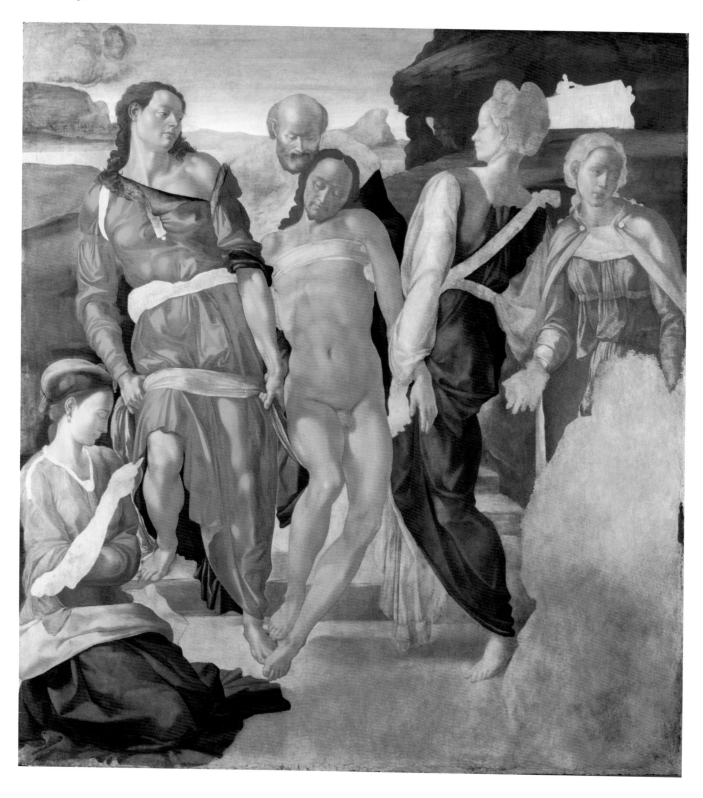

CONSTRUCTION

With so much attention given to the subjects and commissions of altarpieces, it is perhaps easy to forget the importance of their carpentry, particularly as so many of them have been cut into fragments. However, the overall design of an altarpiece was greatly conditioned by its complex and costly wooden structure, which defined its painted surfaces and constrained its composition. The carcass required a considerable investment in terms of both time and labour, and consequently represented a high proportion of the total cost of the entire altarpiece. In other words, changes in the construction of altarpieces affected how they were planned and conceived. Making and gilding the frame of Michelangelo's *The Entombment* (fig. 36) cost nearly as much as the picture itself (fifty ducats as opposed to the sixty ducats paid to the painter).[54] Other examples from elsewhere in Italy can be cited where the frames cost more and also (significantly) were commissioned first.

The wood grain runs, of course, along the length of each plank and a panel would therefore be strongest if the grain, and consequently the planks themselves, run in the direction of its longest side (though this was not invariably the case, especially in Venice and its territories). The planks in Margarito d'Arezzo's panel (figs 37 and 38) of about 1263–4, wider than it is tall, for example, are laid horizontally. In contrast, those of the Master of the Albertini's upright *The Virgin and Child with Six Angels* (fig. 40) of about fifty years later, ran vertically (the painted surface of this picture, originally composed of five planks, was subsequently transferred to canvas). The reverse of any polyptych reveals that two or three vertical boards were fixed together into panels, which generally correspond with the framed and painted panels of the main tier when seen from the front. (The predella plank is typically horizontal.) This 'upright' construction was established in Tuscany in some early altarpieces, such as Giotto's polyptych for the church of the Badia in Florence of about 1310 (now in the Uffizi, Florence) and Duccio's *Polyptych No. 28* (fig. 23, page 40). Although in these early fourteenth-century examples the overall width of the polyptych altarpiece is still greater than its height, the height of the separate panels that make it up is greater than their width, making their vertical planking logical.

37 and 38
Margarito d'Arezzo,
*The Virgin and Child
enthroned, with Scenes of
the Nativity and the Lives
of Saints*, about 1263–4(?)
(front and back)

39 Detail of fig. 37 showing
the Virgin and Child

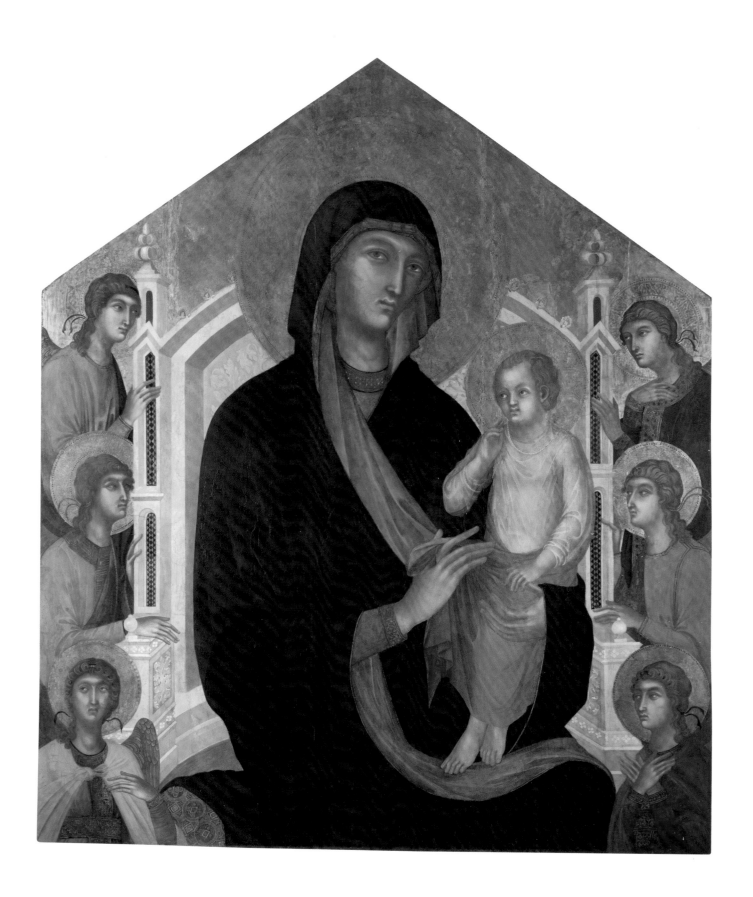

These constructional principles were still unchanged a century later, when Giovanni dal Ponte painted *The Ascension of Saint John the Evangelist, with Saints* (figs 41 and 42). Despite the replacement and regilding of its framing elements in the nineteenth century, this work is arguably the best-preserved polyptych in the National Gallery. The main tier is composed of three vertically planked panels with the scene of the Ascension of Saint John at the centre, and two flanking groups of four saints, each comprised of two poplar planks. One advantage of this construction method is that the individual panels could be painted and transported separately, and assembled on site.

The composition of the panels changes, however, from one polyptych to the next. In *The Ascension of Saint John the Evangelist, with Saints* these panels rise up to just below the pinnacles, which are themselves separate from the main tier, to which they were once attached by vertical battens (but now secured with modern metal brackets). This is not always the case. In certain polyptychs, such as Ugolino di Nerio's *Santa Croce Altarpiece* (fig. 43), the planks of the main tier continue up through a second tier of saints and right into the pinnacles. In such cases everything above the predella box was attached to a single series of vertical planks. Conversely, a second storey, sited between the main tier and the pinnacles, might have been treated as a separate horizontal unit linked by '*ponticelli*', literally 'little bridges', that held in place small vertical battens, as was the case with Jacopo di Cione's high altarpiece for San Pier Maggiore (fig. 29, page 48).

These vertical panels support the mouldings that frame the painted representations on the front. Were the main tier paintings to be removed, the mouldings would move with them as they are structurally dependent on the elements that constitute the painted surface. Once these vertical elements had been primed with gesso, gilded, tooled and painted, they needed to be locked together. On small pictures, such as Jacopo di Cione's *The Crucifixion* (fig. 48, page 70), this assembly probably occurred at the outset, while on larger works, such as the *San Pier Maggiore Altarpiece*, they would only have been assembled in place above the altar.

The mechanisms used to stabilise these unwieldy structures differ widely. In general, however, a secondary framing system of upright columns was placed between each of the panels with more prominent lateral piers (or '*colonne*' as they are sometimes called) at either end. Horizontal battens were then attached to the back of the polyptych, forming a notional grid of uprights and cross-beams with the vertical panels sandwiched between them. In the case of *The Ascension of Saint John the Evangelist, with Saints*, the battens run below the shoulder and along the base of the altarpiece. Each batten is made of three

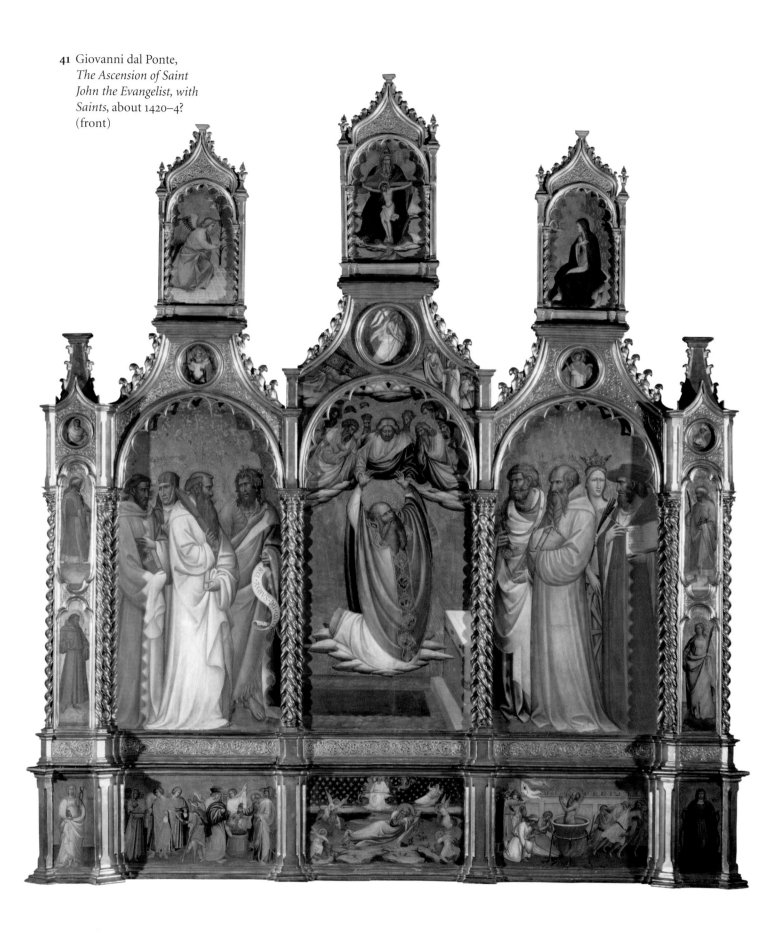

41 Giovanni dal Ponte, *The Ascension of Saint John the Evangelist, with Saints*, about 1420–4? (front)

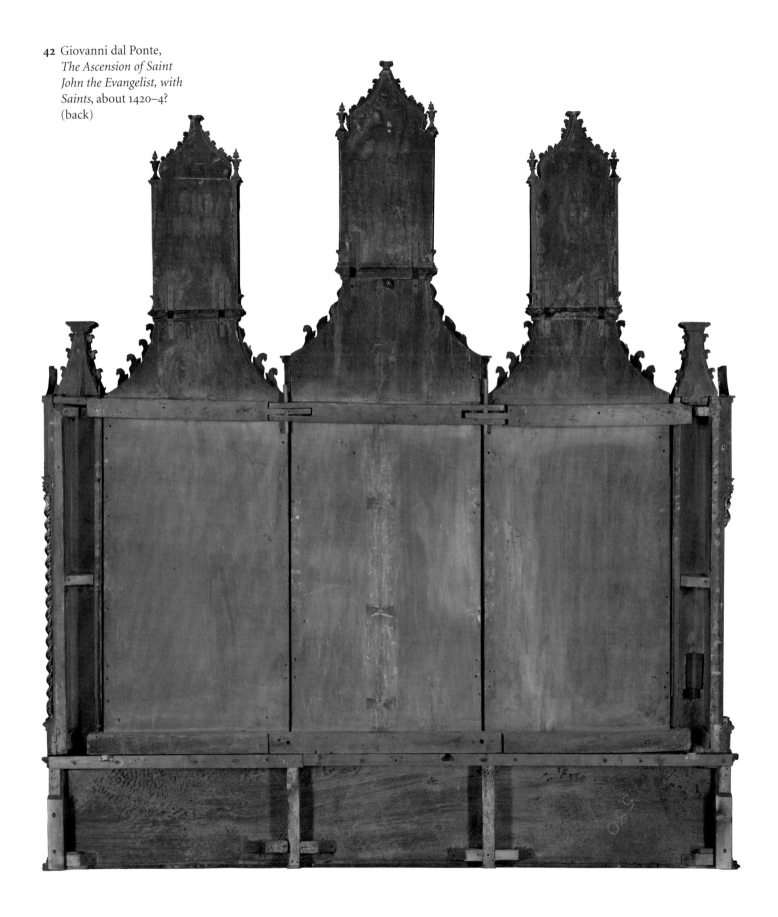

42 Giovanni dal Ponte,
*The Ascension of Saint
John the Evangelist, with
Saints*, about 1420–4?
(back)

43 Ugolino di Nerio, *The Santa Croce Altarpiece*, about 1325–8(?)

The National Gallery fragments have been superimposed over a drawing by Humbert de Superville, 1790 (Biblioteca Apostolica Vaticana).

44 **opposite**
Detail of *The Deposition* from the *Santa Croce Altarpiece*

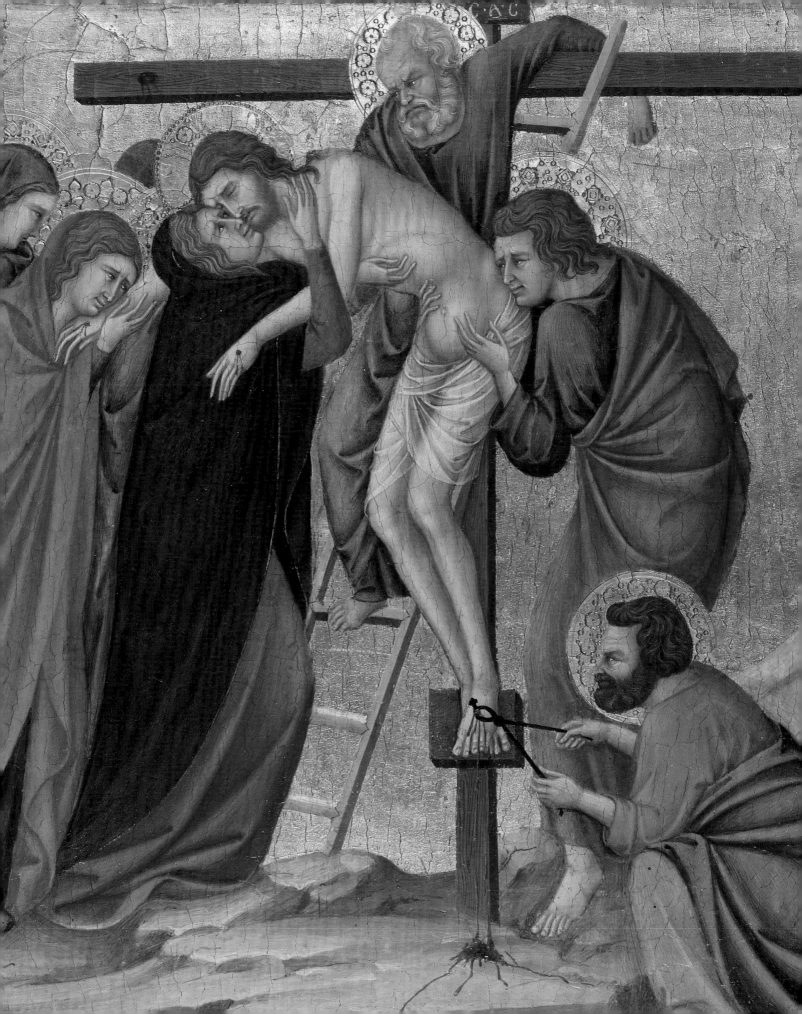

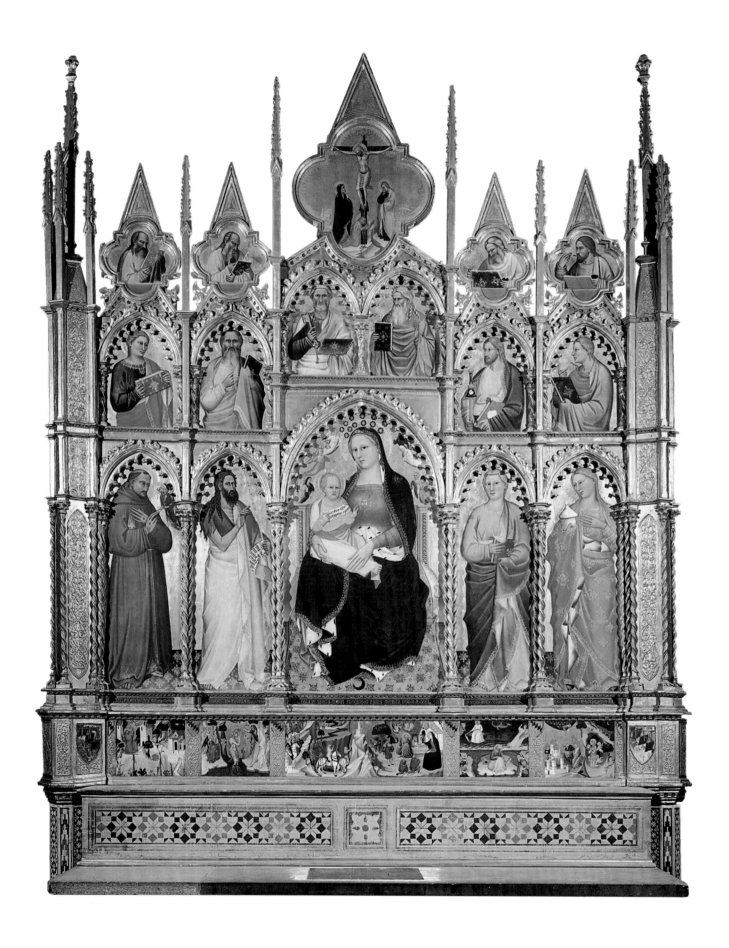

pieces joined by interlocking 'teeth' pegged together with dowels. These pieces correspond to the individual panels. Thus each batten could be attached to the back of a panel during construction and before the more delicate operations of gilding and painting, but only pegged together once the altarpiece was ready to be assembled.

In cases where the altarpiece was designed to be wider than the altar table, the lateral piers often continued down to the floor, where they were fastened for additional support. A payment record exists, for example, to a certain Niccolò, a paver, for making holes, presumably in the floor to secure lateral piers, when Jacopo di Cione's altarpiece was installed on the high altar of the church of San Pier Maggiore in Florence.

The use of flanking supports may have been introduced with the installation of Duccio's *Maestà* (fig. 27, page 46) on the high altar of Siena Cathedral in 1311.[55] However, such supports only rarely survive: the only painted polyptych to retain them relatively intact is Giovanni del Biondo's altarpiece painted for the Rinuccini Chapel in the sacristy of Santa Croce (fig. 45). Their structural importance should not be underestimated, for they allowed for a new verticality which came to dominate altarpiece design and marks a decisive shift from the horizontal emphasis of earlier single-tier polyptychs.

Although the structure described above is typical of polyptychs constructed in the late fourteenth and early fifteenth centuries, a multitude of variations also existed. In the case of double-sided altarpieces, such as Sassetta's polyptych commissioned by the friars of San Francesco in Borgo San Sepolcro (fig. 46), the back could not have been secured with battens and the structure would probably have been stabilised by the combined effect of the piers and substantial pilasters between the panels of the main tier. By contrast, in a smaller work, such as Jacopo di Cione's exceptionally well preserved *The Crucifixion* (fig. 48), the predella, central panel, flanking saints and canopy might all be treated as a single unit, with only the lateral piers assembled separately. Irrespective of these differences, what defined the polyptych was its complex structural unity, despite the visual effect of many separately framed panels. With the exception of the predella, no one element existed independently of another.

The construction of the *pala* is quite different, consisting of two basic components: the frame, of which the predella is a distinct unit, and the rectangular panel. The main panel is composed of several vertical planks of poplar joined together; unlike the polyptych, the *pala* frame is not structurally dependent on the painted panel. Consequently, the central panel, made separately, could be removed from its frame, which would remain upright,

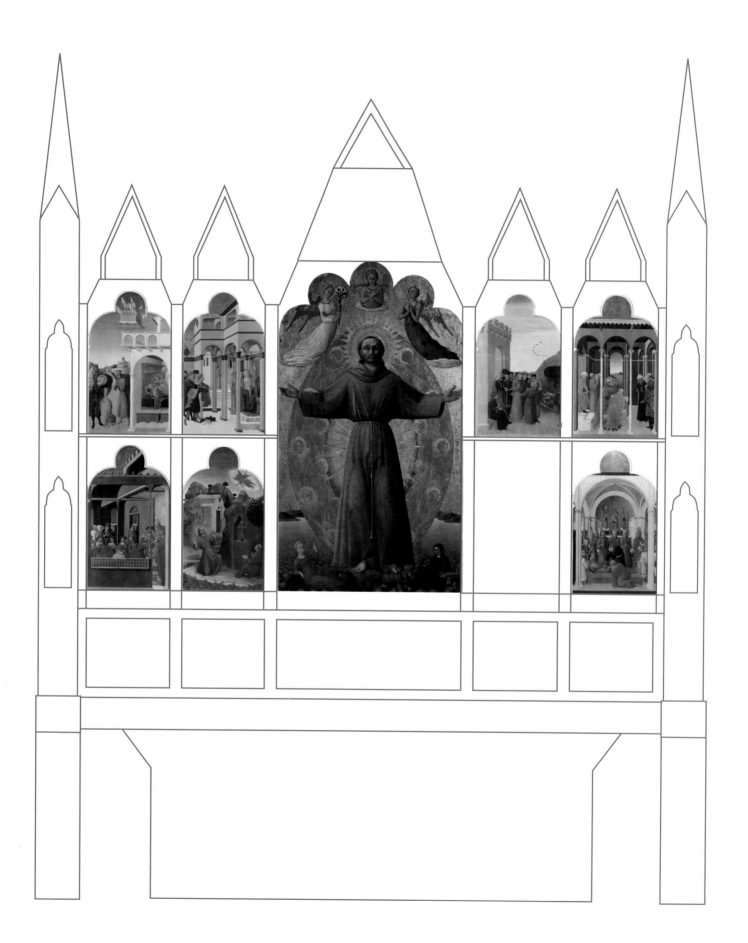

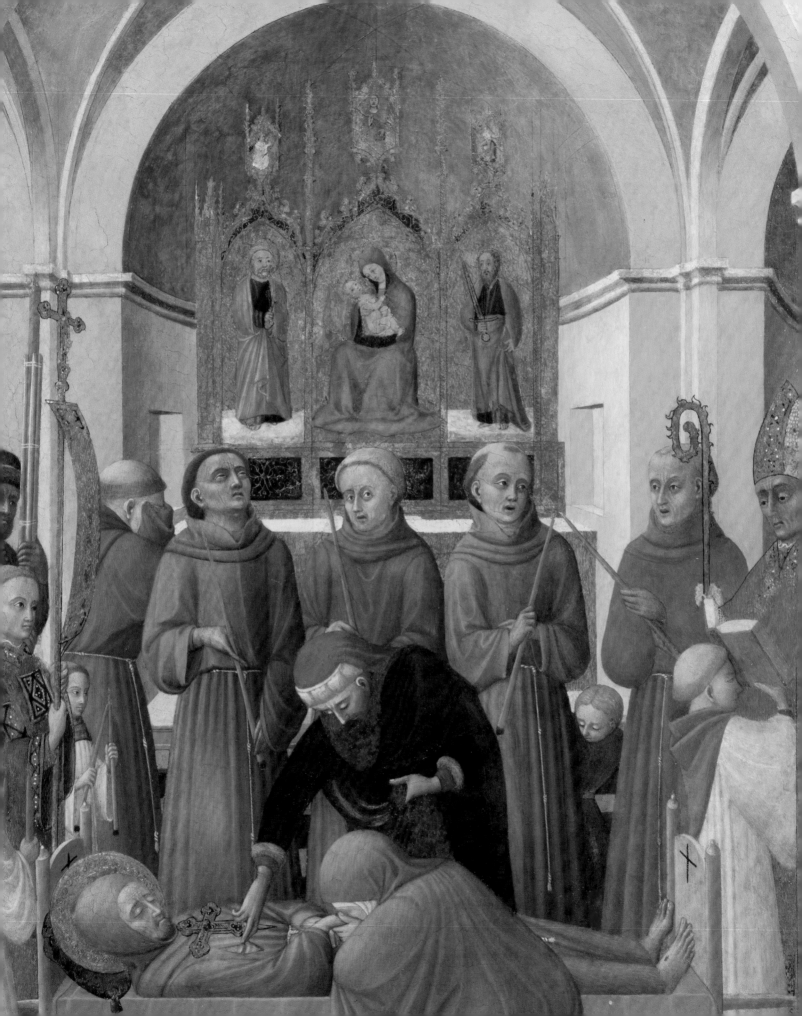

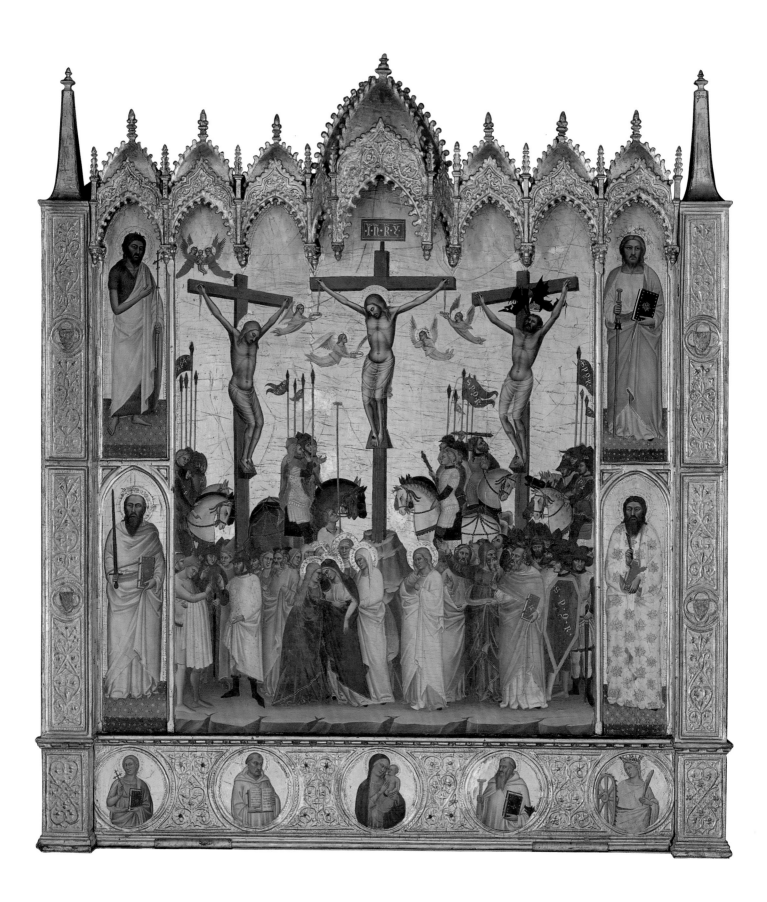

appearing like an open window in a solid wall. The same could not be said of the frame of a standard Tuscan polyptych.

The panel of Botticini's *pala* for the *San Gerolamo Altarpiece* (fig. 31, page 50), unlike many others, has retained its original proportions. Dribbles of gesso running down the edges of the main panel indicate not only that it has retained its original dimensions, but that it was gessoed out of its frame (which was not the case with Tuscan polyptychs). Running horizontally across the back of the main panel are two battens set into trapezoid grooves (fig. 49), presumably intended to reduce warping and secure the panel into the frame in much the same way that they would on a polyptych (although this is not certain: the battens have been cut and the internal uprights of the frame replaced, leaving no sign of the original fixings; indeed, although once considered one of the National Gallery's finest Renaissance frames, its authenticity is now a moot point). Similarly, the figure of Saint Jerome on the front shares the same picture surface as the surrounding saints, despite giving the impression of being a separately framed picture. No evidence of this inner frame surrounding Saint Jerome is evident on the back, suggesting that it must have been nailed on to the front before gessoing and gilding began.

The painted panel of a *pala* is, therefore, distinct from its rectangular frame, which provides the structural support for the altarpiece. This constructional change from the polyptych had important implications for the division of labour between the *legnaiuolo*, or woodworker (fig. 50), and the painter, who could now work independently on the frame and main panel respectively. We know that Giuliano da Maiano's tabernacle frame for Domenico Ghirlandaio's *Innocenti* altarpiece, for example, was supplied after the artist had painted the main panel, while the predella, which is integral to the frame, was painted slightly later by another artist, Bartolomeo di Giovanni.[56]

The main panel of Carlo Crivelli's *The Madonna of the Swallow* (fig. 56, page 83) presents a special case in terms of construction, for it seems that it originally had an integral moulding attached to it that was independent of the frame, rather like the construction typical of a polyptych. Sadly, the main panel has been severely thinned and was previously cradled in a wooden framework by conservators (to prevent the wood from warping or separating), so it is difficult to establish precisely how it was originally secured within its frame, although a groove in the base of the predella box might indicate that the panel originally extended right down into this slot. During restoration the bottom right corner of the main panel was found to have marks of brown paint and vermilion over gold. The gilding is thought to have been the residue of a fixed

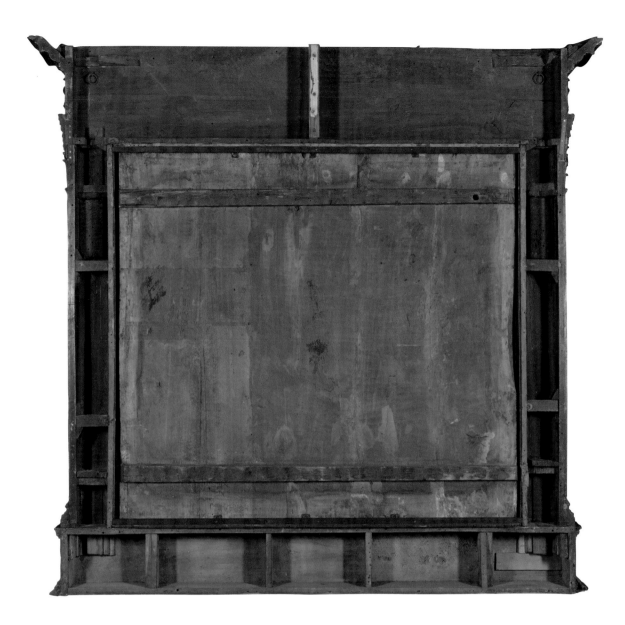

49 Francesco Botticini, *San Gerolamo Altarpiece*, about 1490 (back)

50 Detail of fig. 49 showing brands thought to be that of the *legnaiuolo* (woodworker)

frame attached to the panel that was separate from the encasing tabernacle frame.[57] So although this painting survives in its original frame – one of the few examples in the National Gallery – its original construction reflects an intermediate step between the two types. It is surely significant that Crivelli and his workshop produced both *pale* and polyptychs.

STRUCTURE AND COMPOSITION: THE POLYPTYCHS OF BORGO SAN SEPOLCRO

An understanding of the process of construction of an altarpiece, and the order in which the various elements were executed, in turn sheds light on the issues faced by the artists who painted them. The altarpieces of San Francesco and Sant'Agostino in Borgo San Sepolcro are a case in point. In 1426 the friars of San Francesco commissioned a carpenter to build the wooden framework for their high altar, instructing him to model the structure on Niccolò di Segna's polyptych on the high altar of the Camaldolese abbey in the same town. Following a series of complications, the prepared panel remained unpainted until the artist Sassetta was newly awarded the commission. However, he rejected the pre-prepared wooden casing and had another made in Siena, which he arranged to be transported, once painted, to San Francesco in 1444 (fig. 46, page 68).[58] In the meantime, the friars of San Francesco sold the incomplete structure to their fellow mendicants at Sant'Agostino, who gave it to Piero della Francesca for painting, twenty-eight years after it had been first assembled. Piero's representation of the saints in separate panels (figs 91 and 92, page 116), without the kind of interaction between figures more commonly depicted at this later date, was surely dictated by the fact that he was working on a pre-existing structure that had no doubt been conceived for a very different style of painting.

THE COMMISSION
AS A SOCIAL CONTRACT

51 Detail from Benozzo Gozzoli, *The Virgin and Child enthroned among Angels and Saints*, 1461–2

Altarpieces required close collaboration and coordination between patrons, painters and carpenters, as well as notaries to authorise the agreements between them, and a seemingly endless list of people to transport them – sometimes across long distances – haul them onto altars and fix them in place. Furthermore, if the patrons were nuns in enclosed orders the process became even more complicated, requiring an intermediary to communicate their needs to the outside world. These various individuals came from different economic backgrounds and often moved in very different social circles. Yet, of these rich and varied dealings, friendly conversations, formal discussions and heated arguments, very little remains. Certainly contracts survive in considerable numbers and can be useful gauges of problems that had to be overcome, particularly when they were amended or contained unusual clauses. However, they are legal documents and only record the final, agreed outcome between two or more parties, rather than the daily relationships between people. The same applies to contract drawings, although few of these now survive. More often than not, the sole remaining 'document' is the altarpiece itself.

52 Ambrogio Bergognone,
*The Virgin and Child
with Saint Catherine of
Alexandria and Saint
Catherine of Siena,*
about 1490

By examining what decisions were made, such as the choice of saints to be depicted, it is possible to demonstrate that these visual remnants of the past are in themselves important social documents. Such decisions were highly conscious and can be interpreted as demonstrations of the devotion, aspirations and allegiances of one, or several, individuals, brotherhoods, communities or entire societies having a vested interest in the altarpiece. Many factors influenced their choice of saint: the dedication of the altar; the saints to whom patrons were devoted, especially their namesakes; or the saints who were of importance to the church or community for which the altarpiece was commissioned. Thus at the Certosa di Pavia, a Carthusian monastery complex in Lombardy, Ambrogio Bergognone's altarpiece for a chapel dedicated to Saint Catherine of Alexandria and Saint Catherine of Siena showed these two saints (fig. 52). Similarly, the high altarpiece painted for a Camaldolese nunnery dedicated to Saint John the Evangelist (fig. 41, page 62) depicted his ascension between saints who were either of importance to the Camaldolese community or related to religious houses that came under their control.

Very often, more than one individual or community vied for prominence. In the case of the well-documented *Trinity Altarpiece* (fig. 75, page 102) painted by Francesco Pesellino, Fra Filippo Lippi and their respective workshops for the church of the Compagnia della Trinità (the company of priests dedicated to the Holy Trinity) in Pistoia, it was decided that the composition should centre on the Holy Trinity, flanked by two saints on either side. The saints selected included the patron saint of Pistoia (James), the patron saint of the clergy of Pistoia (Zeno) and Saint Jerome, either in homage to the canon of the cathedral, Gerolamo d'Andrea Zenoi, or as an evocation of Jerome's vision of the Holy Trinity. The fourth saint appears to have been selected by the treasurer of the Compagnia della Trinità, Pero ser Landi, who pleaded for the inclusion of Saint Mamas to whom he was especially devoted. The altarpiece is consequently the visual manifestation of the interaction between the members of the company, as well as a document of their civic pride in Pistoia. But altarpieces should not be considered a passive reflection of historical facts: in many cases they came to play an active role in the society for which they were created.

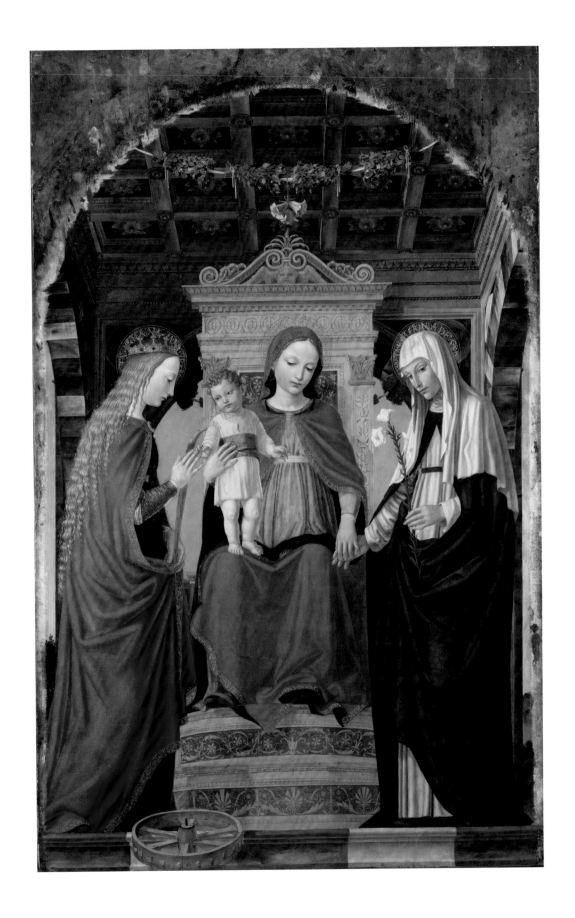

RIVAL CONCERNS

Of course, these generalisations about the social pressures of commissions apply not only to altarpieces, but to all objects for which money was exchanged, from the high altarpiece of San Pier Maggiore to the handkerchiefs that feature so prominently in fifteenth-century inventories. But altarpieces, like chapel decoration more generally, present a special case. They were often located in a space over which lay patrons had rights but not ownership. Consequently, patrons would frequently have to negotiate with ecclesiastical authorities not only regarding space, but also over the imagery that decorated them. In cases where members of a particular order were likewise the patrons of a chapel or altar, or where an altarpiece was destined for a chapel in a private palace, such decisions might have been more easily resolved. However, domestic chapels were rare and required an episcopal dispensation even to exist – in fifteenth-century Florence, for example, only the Palazzo Medici and the Palazzo Scala are known to have had chapels and they are both exceptional buildings.

No contract has ever been found for the altarpiece that Francesco Botticini supplied to the church of San Gerolamo, the principal house of the Hermits of Saint Jerome of Fiesole (fig. 31, page 50).[59] All the same, it is known that the work was originally placed on the first altar on the left side of the nave and was probably commissioned by Gerolamo di Pietro di Cardinale Rucellai (1436–97), whose coat of arms flanks the predella. In the main tier, Gerolamo Rucellai is represented kneeling in prayer to the left of the central framed image of Saint Jerome. In the corresponding position on the right is his son, Giuliano. Rucellai also commissioned the tabernacle (in which the consecrated host was stored) for the sacristy of San Gerolamo, now in the Victoria and Albert Museum (V&A 6743–1859), and he was buried in a multi-coloured marble tomb in front of the altar.[60] It is clear, even in the absence of the contract, that the interests of the patron were represented through the inclusion of portraits, coats of arms at the ends of the predella (fig. 53), and the Rucellai family emblem, the diamond ring interwoven with feathers, carved on the frame (fig. 54). Gerolamo Rucellai was presumably also remembered in the Masses said before the altar, for which he very probably bequeathed money. Patrons' primary motivation for decorating chapels, commissioning altarpieces and leaving money for Mass to be said – in short, for commemoration – was to ensure their own salvation by reducing their time in purgatory.

Gerolamo Rucellai's interests were clearly also invested in his name saint, Jerome, who takes pride of place at the centre of the altarpiece. Both Gerolamo

53 Detail of Francesco Botticini's *San Gerolamo Altarpiece* showing the Rucellai coat of arms in the predella panel

54 Detail of Francesco Botticini's *San Gerolamo Altarpiece* showing the Rucellai *impresa*, the diamond ring interwoven with feathers

and his son are depicted in perpetual devotion to the saint; or rather, to an image of the saint whose framework and discontinuous landscape draw attention to its very status as an independent painted image, in the customary position of the Virgin. This arrangement was perhaps chosen as a resolution to the compositional difficulty of inserting a penitential saint within a desert landscape into the static company of other figures. As such, the donors' veneration of Saint Jerome becomes a model for the pious visitor standing before the altarpiece itself.

As well as being his patron's namesake, Saint Jerome was naturally of great importance to the Hieronymites (or followers of Saint Jerome) who lived and worshipped at San Gerolamo. It is their interests that appear to have determined the choice of the somewhat lesser-known saints in the altarpiece. From left to right they are: Saint Eusebius of Cremona (Jerome's friend and supporter against Origen, an early Christian theologian whose writings Jerome came to reject); Saint Damasus (the pope who commissioned Jerome to translate the Bible); Saint Paula (a follower of Jerome who became abbess of a nunnery he founded in Bethlehem); and Saint Eustochium (Paula's daughter and Jerome's pupil, who succeeded her mother as abbess at Bethlehem). With the exception of the pope they are all dressed in the grey habit of the Hieronymites of Fiesole.

Although the *titulus* of the altar above which this work once stood is not known, it was in all likelihood one of these saints. It was presumably not Saint Jerome, to whom the church was dedicated, since he was most likely the *titulus* of the high altar. None of the name saints of other members of the Rucellai family, most notably Gerolamo's son Giuliano, was represented, nor were saints of local importance, such as the patron saints of Fiesole or nearby Florence. The appearance of the altarpiece therefore strongly reflects the interests of the order – more so, perhaps, than those of the patron or the wider community.

BALANCED INTERESTS

Where contracts do still exist, the balance between ecclesiastical and lay interests can be better understood. Carlo Crivelli's altarpiece known as *The Madonna of the Swallow* (fig. 56) was painted for the Ottoni Chapel in the nave of the church of San Francesco in Matelica, a small town in the Marche, of which the Ottoni were the local ruling family.[61] The chapel was unusual in having a large arched window on the back wall, which meant that the altar and its accompanying altarpiece had to be placed along one of the lateral walls. In this case the

55 Detail of fig. 56 showing the Ottoni coat of arms and Carlo Crivelli's signature

chapel had two altars, one on each side. That on the right, when entering the chapel, supported a triptych attributed to Francesco di Gentile da Fabriano, which remains there to this day. Crivelli's *The Madonna of the Swallow*, still in its original Renaissance frame, was commissioned for the altar opposite. Approaching the altarpiece from the side, as dictated by its original location, it becomes clear that the light depicted as entering the composition from the upper right is intended to suggest the actual light originally filtering into the chapel from the adjacent window.

In the nineteenth century the Ottoni Chapel was dedicated to Mary, mother of God, and it bore a Latin inscription 'MONSTRA TE ESSE MATREM' ('Show thyself a mother') over the entrance arch. There is no reason to suggest that the chapel held a different dedication in the fifteenth century, particularly as the representation of the Virgin and Child in Crivelli's altarpiece complements the dedication so well. The central panel of the predella, which is directly beneath the Virgin and Child, reinforces the theme with a Nativity showing the Virgin's adoration of her son. The Ottoni coat of arms is conspicuously located on the same axis, midway between the Virgin and Child and the Nativity (fig. 55), as if to commend the family to her care and protection and to underline their presence in the chapel.

Dated 11 March 1491, the contract with Crivelli reveals that the expense of the altarpiece was to be shared between Ranuccio Ottoni (co-ruler of Matelica with his uncle, Alessandro) and Fra Giorgio di Giacomo, guardian of the Conventual Franciscans in Matelica.[62] However, Fra Giorgio paid far more than the patron

of the chapel (the altarpiece cost 310 florins, of which Ranuccio Ottoni paid only 60 ducats). This unbalanced division of expenses is probably explained by the fact that the Ottoni had already paid for the other altarpiece in the chapel, the painting attributed to Francesco di Gentile da Fabriano. The two saints flanking the Virgin and Child in Crivelli's altarpiece, Jerome and Sebastian, reflect this joint enterprise. They divide the altarpiece into two halves on either side of the Marian axis, the left clerical, the right lay. Dressed in his customary robes – those of a cardinal – Saint Jerome carries a miniature model of the church, while Saint Sebastian is dressed as a knight clutching his sword (fig. 57), rather than being shown in his more typical guise as a nude martyr. The Ottoni had been military captains since the beginning of the fifteenth century, and participated in the tournaments and hunts that played such an important role in court culture. The decision to represent Sebastian as a soldier may be a reflection of an Ottoni desire to promote their own courtly image. The presence of Saint Catherine and Saint George in the predella follows the same division between clerical and lay interests. Saint Catherine was the patroness of theological learning, and consequently an appropriate saint to reflect the left-hand, clerical, side of the altarpiece; Saint George, a soldier like Sebastian, was the most chivalric of saints and placed on the right.

The contract for the altarpiece included a third signatory, whose interests have not yet been considered but which were plainly inscribed on the panel: the painter himself. Quite apart from his 'signature style', Crivelli signed his work prominently and strategically beside the Ottoni coat of arms: '. CAROLVS . CRIVELLVS . VENETVS . MILES . PINXIT .' He proclaimed himself as Venetian, despite his long exile from that city. What is more, through the Latin word *miles* (soldier, knight) he reminded the viewer of the knighthood recently bestowed on him by Prince Ferdinand of Capua. It may be significant that his signature appears shifted to the right, beneath Saint Sebastian and above Saint George (fig. 55).[63]

The composition of the altarpiece and its range of saints, however, must have had different associations and resonances for different viewers. Saint George, for example, is also the name saint of the patron Fra Giorgio, while the presence of Saint Sebastian probably also recalled his traditional role as defender against the plague: the town of Matelica had only just recovered from a devastating outbreak. Curiously, there is nothing in the picture to recall its commission for a Franciscan church. In contrast to Botticini's *San Gerolamo Altarpiece*, Crivelli's appears to prioritise the interests of its two patrons and his own newly ennobled artistic status over those of the Franciscan order.

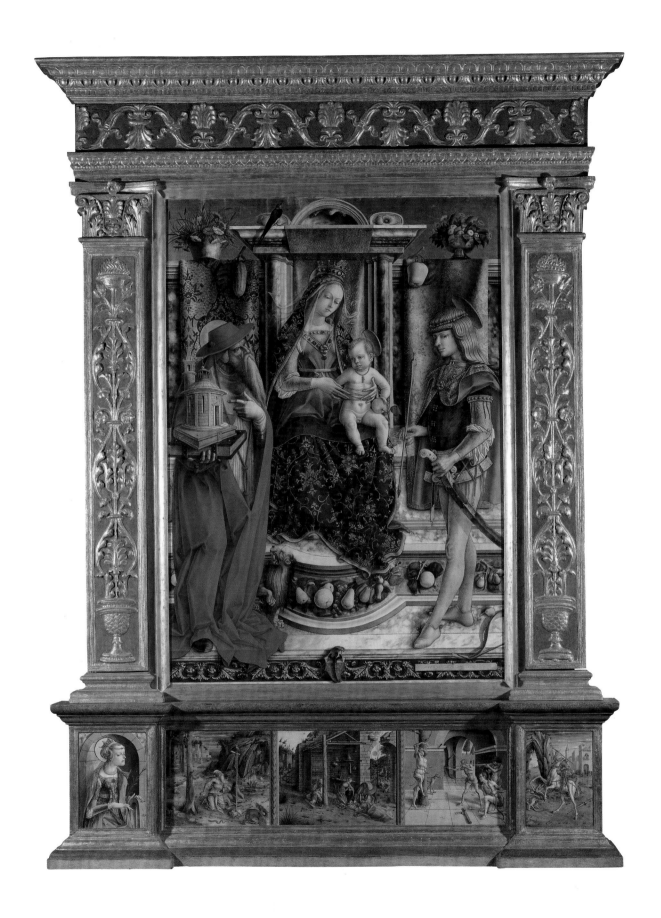

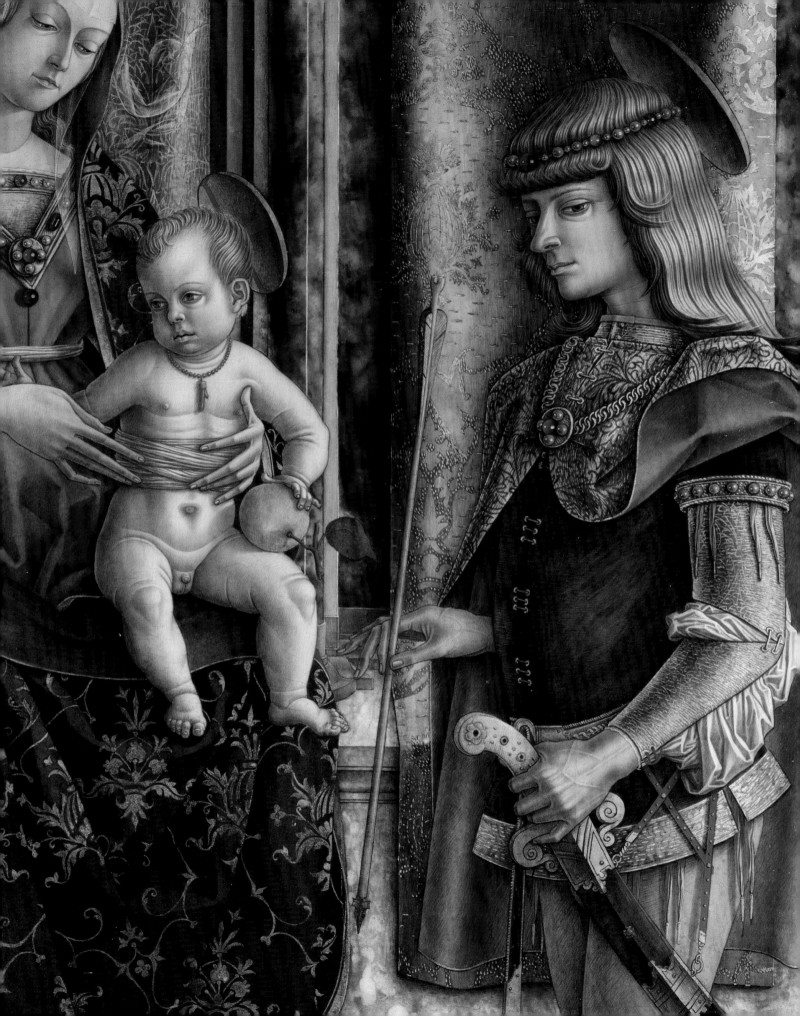

57 Detail of fig. 56 showing
Saint Sebastian depicted
as a knight

A CORPORATE ENTERPRISE

Altarpieces might reflect not only the interests and allegiances of the patron, but also his or her social position, particularly when the 'patron' was a group rather than an individual. In this sense, altarpieces may be considered as a visual embodiment of social relationships. On 23 October 1461 the brethren of the Confraternity of the Purification of the Virgin and of Saint Zenobius contracted Benozzo Gozzoli to paint an altarpiece for their meeting room in the precinct of San Marco, the convent of the Observant Dominicans in Florence (figs 58–63).[64] The young members of the Confraternity were at the centre of a complex web of social ties which included the Dominicans at San Marco, the adult flagellant Confraternity of Saint Jerome, the Medici family and, more broadly, the city of Florence itself. The altarpiece they commissioned reflected – and participated in – this social network: it was the visual expression of their corporate spirit.

Confraternities in this period were incorporated lay institutions, which wrote up statutes and collected dues from their members. In the case of the Confraternity of the Purification, the members were adolescent boys (even if fifteenth-century definitions of adolescence are not quite our own). They came from a variety of social backgrounds, although the majority hailed from families involved in the cloth trade. Youth confraternities were generally overseen by adults: the brethren of the Purification were in the charge of a guardian (a linen merchant called Domenico di Stefano, who signed the contract with Benozzo Gozzoli on behalf of the entire company), the Dominicans of San Marco (who sometimes 'recruited' novices from among them), and an adult male confraternity dedicated to Saint Jerome. Keeping their members busy with pious activities, and so out of trouble, youth confraternities performed an important social function and for this reason they were keenly encouraged by Fra Antonino Pierozzi (later Saint Antoninus), prior of San Marco and subsequently archbishop of Florence. The Confraternity of the Purification was even sanctioned by Pope Eugenius IV in 1442, on one of the most important dates in the Florentine calendar, the auspicious feast day of their patron saint, John the Baptist.

The activities of the Confraternity of the Purification were many and varied. They met once a week to celebrate Mass and sing lauds to the Virgin Mary. Although this weekly meeting occurred in private, the Confraternity also played a significant public role. Their statutes make clear that they prayed not only for themselves and their members, but 'for the Holy Church and Our City'. They performed sacred plays, participated in processions, and were obliged to

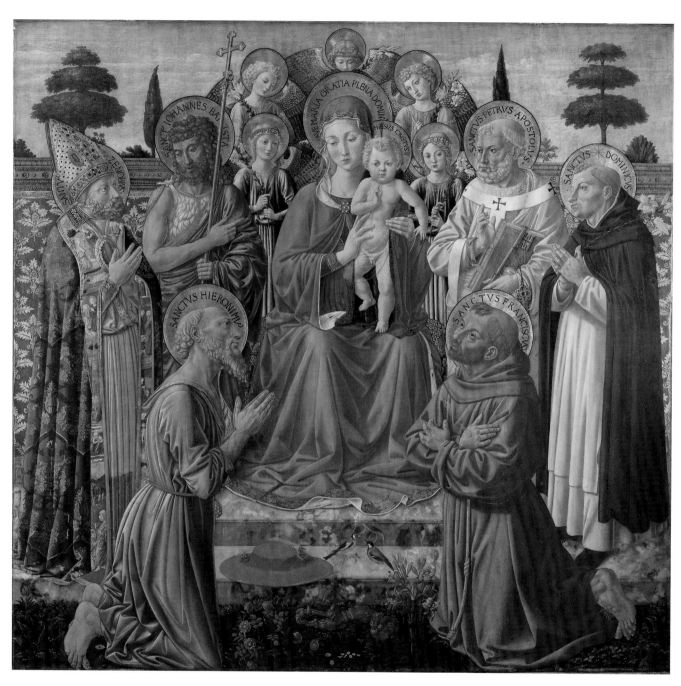

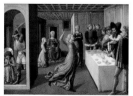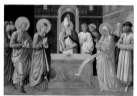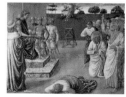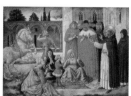

mark with particular ceremony the feasts of the Purification, Saint Zenobius, and Saints Cosmas and Damian. These feasts, two of which were reflected in the Confraternity's dedication, had no doubt been chosen because of their importance to the civic and religious life of the city. The Purification was the principal feast of Florence Cathedral, as well as an important feast day for the Dominicans, who had a particularly strong devotion to the Virgin. Zenobius, the first bishop of Florence, was one of its patron saints and his relics were preserved in the cathedral. Cosimo de' Medici, *de facto* ruler of Florence, had a special devotion to the physician twins Cosmas and Damian: their profession, *medici* in Italian, was a play on his surname, and one of them was his name saint. Cosimo was also particularly involved with both the Confraternity of the Purification and the Dominicans at San Marco, having paid for the restoration and construction of the convent buildings, including the Confraternity's meeting rooms. He was consequently remembered in the high altarpiece for San Marco through the inclusion of the saints Cosmas and Damian (fig. 64). They were, unsurprisingly, also the dedicatees of an altar in the antechamber to the brethren's oratory, which was furnished with an older painting donated by Cosimo de' Medici himself.

The artist chosen to undertake the altarpiece at San Marco was also fully immersed in this patronal and social network. Benozzo Gozzoli was trained by a Dominican friar, Fra Angelico, and while in his workshop had already frescoed some of the friars' cells at San Marco. He had also just completed the murals for the private chapel of Cosimo de' Medici nearby. The contract with Benozzi Gozzoli is unusually detailed and too long to quote in its entirety here. However, the paragraph describing the saints to be included is worth citing in full:

> At first, in the middle of said panel, the figure of our Lady with her seat in the manner and appearance and in attributes in likeness of the panel of the high altar of San Marco of Florence; and on the right side of said panel, next to our Lady, the figure of Saint John the Baptist in his customary dress, and beside him, the figure of Saint Zenobius with the appropriate attributes of Episcopal office, and then, the figure of the kneeling Saint Jerome with his customary attributes; and on the left of our Lady, the figure of Saint Peter, and next to him that of Saint Dominic, with all of the suitable attributes. And with his own hand, the said Benozzo must, as is written above, paint the base, that is, in the predella of the said altar, the stories of the said saints, each one beneath its appropriate saint; and in the shield where it is customary to place the arms of the one who had the panel

64 Fra Angelico,
San Marco Altarpiece
Tempera on panel,
220 x 227 cm
Museo di San Marco,
Florence

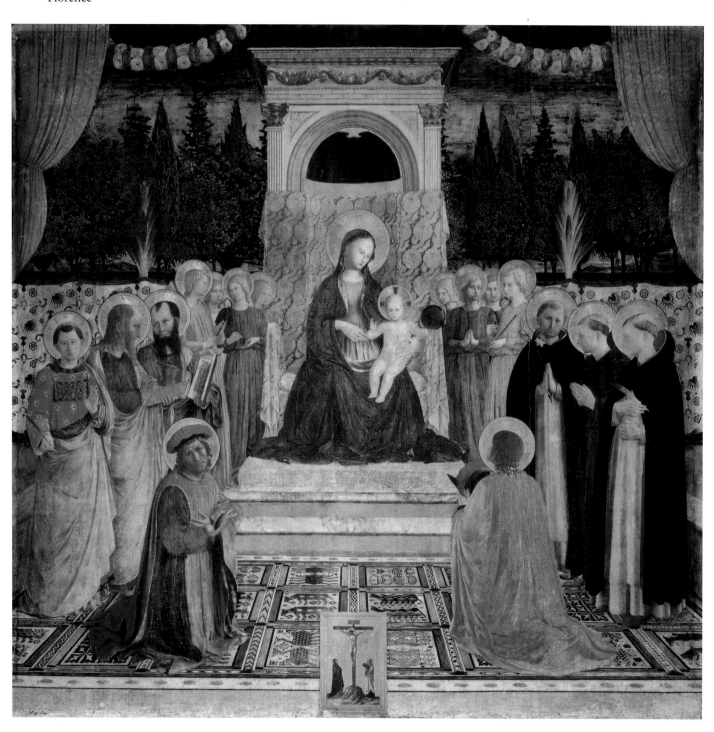

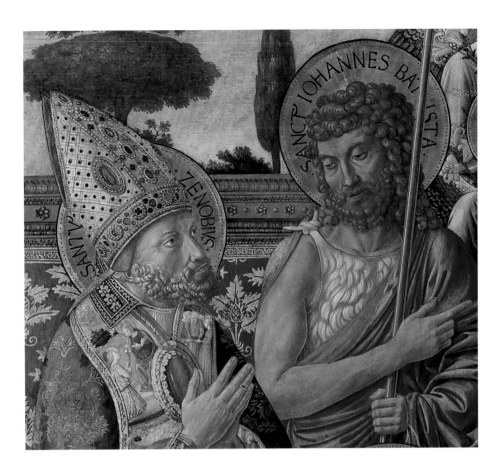

65 Detail of fig. 58 showing Saint John the Baptist and Saint Zenobius

made, must be painted two youths, dressed in white with garlands of olive branches on their heads, who hold in their hands the shield on which these letters are properly inscribed, that is, P. S. M. [*Purificatio Sanctae Mariae*].[65]

Saint John the Baptist and Saint Zenobius, who occupy the honorific position to the Virgin's proper right (the viewer's left; fig. 65), were both patron saints of Florence. Their inclusion is a statement of civic pride and underscores the social role that the Confraternity of the Purification played in the life of the city. Saint Zenobius, moreover, was one of the two dedicatees of the Confraternity. Saint Peter, the first pope, stands for the Church. His role here is perhaps best understood when considered together with Saint Paul, who accompanies Saint Peter in the predella. It was on the joint feast day of Saints Peter and Paul that Cosimo de' Medici had presented the Confraternity with their oratory, and it was on this day following their twenty-fourth birthdays that young men traditionally left the Confraternity. Also on this feast day, Saint Zenobius miraculously resuscitated a young boy, as depicted in the first scene of the

66 Benozzo Gozzoli, *Saint Zenobius resurrecting a Child*, predella panel, 1461 Tempera on panel, 24 x 34 cm Gemäldegalerie, Staatliche Museen Berlin

predella (fig. 66). Tellingly, the chapel dedicated to Zenobius, located behind the high altar of Florence Cathedral, is flanked by chapels dedicated to Saint Peter and Saint Paul.

The Zenobius miracle is paired, at the other end of the predella of the San Marco altarpiece, with a scene showing Saint Dominic's resurrection of a child, a miracle which must have had a particular resonance for a group of young members. The Confraternity's relationship with the Dominicans, not least through the location of their oratory within the precinct of the convent, explains the inclusion of their founding saint in the main panel. Further, Saint Dominic's particularised features suggest that this may also be a portrait, presumably of someone important to the Confraternity.[66] Saint Jerome, dedicatee of the adult confraternity that oversaw the youths, is paired with

the other great penitential saint, Francis; the two kneel together in prayer and adoration of the Virgin, as exemplars of pious humility.

Despite the stipulation in the contract that the altarpiece should include stories of all the saints in the predella, scenes from the life of Saint Jerome and Saint Francis were omitted and replaced with images of the brethren holding their monogram. It may be that narrative scenes from the lives of Jerome and Francis were more easily left out as they had already figured as models for emulation in the main panel. The young members of the Confraternity were presumably intended to follow their example, just as novices at San Marco would meditate in their cells upon images of Saint Dominic alone at prayer, gesturing beneath the crucified Christ.[67]

For the central panel, the contract mentions only the Virgin; the inclusion of the Christ Child would have been understood. Her role as intercessor between members of the Confraternity and her son is implied through gesture and glance. Thus the artist established another set of reciprocal relationships as, in exchange for their devotion, the Virgin intercedes on the viewers' behalf. Christ's blessing gesture addresses the devotee before the altarpiece, while his raised right foot, pressed against the Virgin's womb, recalls his origin and consequently harks back to the ceremony of the Purification. According to Saint Luke's Gospel (2:22), Mary and Joseph took Christ to the temple in order that Mary should undergo the ceremony of Purification, as required by the Law of Moses, after giving birth to a child, and offer a sacrifice of thanks for her son. The same Gospel recounts how this rite was performed simultaneously with Christ's Presentation in the Temple, a scene appropriately depicted in the central scene of the predella below. The contract further stipulated that the Virgin was to be painted 'in likeness of [*modo et forma*] the panel of the high altar of San Marco of Florence'. Yet the San Marco high altarpiece is very different from the picture in the National Gallery. Clearly the contractual clause was not to create a slavish copy, but rather to establish a relationship between the two altarpieces. In turn, this association necessarily brought both altarpieces into the complex network of relationships embedded in each, between the Dominicans, the Medici, the City of Florence and youths of the Confraternity of the Purification. And, in turn, it illustrates how an object – in this case, the San Marco high altarpiece – could exert power over another object; in short, it demonstrates how an object might act independently or have 'agency'.[68]

1107. The Crucifixion
By NICCOLÒ DA FOLIGNO. B.1430? D.1502?
UMBRIAN SCHOOL.
Painted 1487.

DISLOCATION, DISMEMBERING AND DISMANTLING

67 Niccolò di Liberatore, *Christ on the Cross, and Other Scenes*, 1487

In 1881 the National Gallery acquired from Maria Gianzana an altarpiece signed by Niccolò di Liberatore (fig. 67). The transaction was brokered by the prominent Roman dealer, antiquarian and goldsmith Alessandro Castellani, who wrote to the Gallery's Director, Frederic Burton, a few months after the deal had been concluded. The vendor had ascertained that the picture had been stolen from a convent in L'Aquila, so Castellani requested that the contract be annulled. The Lords and Commissioners of Her Majesty's Treasury replied that they would not void the agreement, nor would they reconsider the matter unless the convent itself appealed directly to the Gallery with sufficient proof of their ownership. On 1 May 1882 the Director reported to the Trustees that Castellani had written again, this time to inform them that, somewhat mysteriously, the matter would be pursued no further; it seemed that the picture had been legitimately purchased after all.[69]

Whether this was indeed the case, or whether the nuns of Santa Chiara in L'Aquila had been appeased by some other means, is not known. Regardless, the incident demonstrates the potentially dubious machinations that sometimes characterised the sale of Italian pictures in the nineteenth century. On this occasion the work escaped deportation back to Italy. It also evaded extensive alteration. With the exception of the addition of a new base and some attempts to brighten the gilding – 'restorations' that were probably undertaken once it arrived in London – this is one of the better preserved altarpieces in the Gallery, even retaining its original hinges. Others, however, were less fortunate. The art market responded to the demand for Italian 'primitives' by ruthlessly hacking them up, extracting saleable elements and discarding the rest.

ALTERATION, FRAGMENTATION AND SALE

It is important to note that such butchering could occur at any point in the history of an altarpiece. Despite the fact that the seventeenth century is not generally thought of as a period in which works of the early Italian school were subject to systematic alteration, it was probably at this time that Masaccio's *Saints Jerome and John the Baptist* (fig. 68) and Masolino's *A Pope (Saint Gregory?) and Saint Matthias* (fig. 69), once the front and back of a single panel, were sawn apart. The Farnese family in Rome were already hanging them as independent pictures in their collection by 1644, by which time the panels' relationship to an altar in the Roman papal basilica of Santa Maria Maggiore had largely been lost.

Some altarpieces were altered very early in their history. Fra Angelico's high altarpiece for San Domenico near Fiesole went through two phrases of dismemberment and reconstruction, one in the early sixteenth century, the other in the nineteenth. The altarpiece was originally a polyptych, but around 1501 the painter Lorenzo di Credi reconfigured it as a *pala* (fig. 70). This meant not only modifying the carpentry, but also rethinking its entire structural and compositional logic. The main panels, originally arched, were built up into a self-supporting rectangle with the addition of horizontal planks at top and bottom, while Fra Angelico's original predella was reincorporated into the re-fashioned altarpiece. Certain elements from the earlier frame seem to have been saved, including *Saint Alexander* (Metropolitan Museum of Art, New York) and *Saint Romulus* (fig. 93, page 117) and, less probably, the *Blessing Redeemer*

68 Masaccio, *Saints Jerome and John the Baptist* from the *Santa Maria Maggiore Altarpiece*, about 1428–9

69 Masolino, *A Pope (Saint Gregory?) and Saint Matthias* from the *Santa Maria Maggiore Altarpiece*, about 1428–9

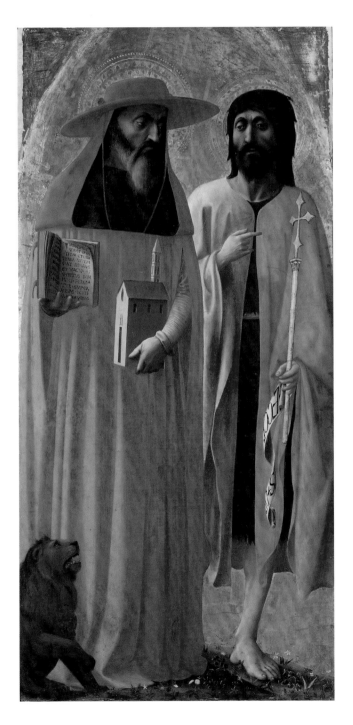

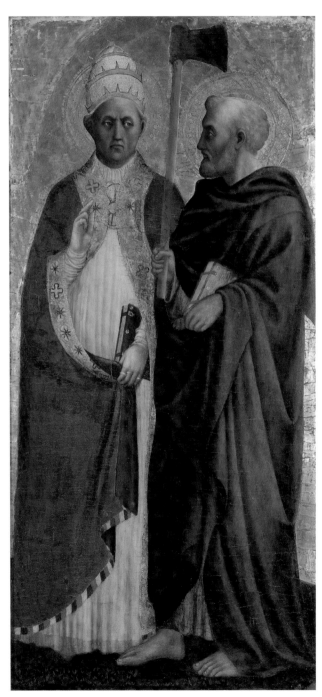

70 Fra Angelico, *The Virgin and Child enthroned with Angels and Saints Thomas Aquinas, Barnabas, Dominic and Peter Martyr* from the *San Domenico Altarpiece*, about 1422, modified by Lorenzo di Credi in 1501
Tempera on panel, 212 x 237 cm
San Domenico, Fiesole

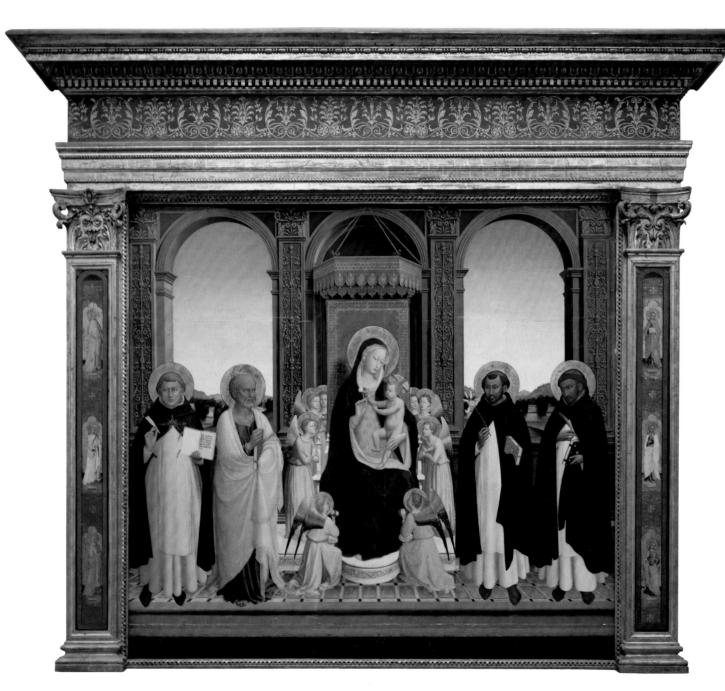

71 Fra Angelico, *Blessing Redeemer*, about 1423

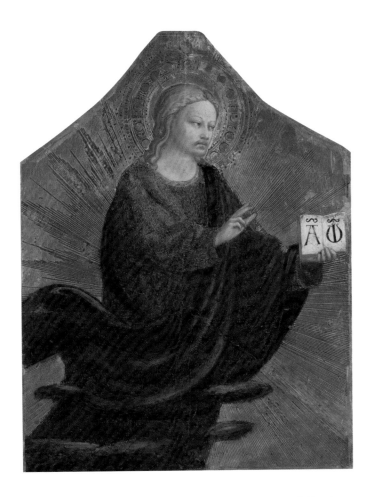

71 Fra Angelico, *Blessing Redeemer*, about 1423

(fig. 71). Why these fragments were preserved is difficult to ascertain, but it is conceivable that the friars transferred them to their cells as aids to private devotion, especially given the high regard in which they must have held the artist.[70] The radical transformation of Fra Angelico's polyptych occurred at the same time as the choir of San Domenico was being rebuilt, and was most likely the result of a desire to update, but not replace, a much-loved altarpiece executed by a painter who had once also been prior of the convent. Although the entire *pala* was removed from the high altar in 1612 and replaced by a wooden ciborium (a vessel with a cover used to hold the Eucharist), the predella remained with it until around 1827. At this point it was sold and replaced by a copy, probably by the forger Michele Micheli. A similar fate befell the pilasters, although they were substituted with period fragments rather than copies, thought to be by Lorenzo di Bicci. By 1860 the predella had been acquired for the National Gallery.

Altarpieces were typically dismembered when they were moved from their original location. High altarpieces were especially prone to such treatment,

as were altarpieces located on or around rood screens. The rearrangement of churches in the sixteenth century, often in response to reforms enacted by the Council of Trent (see page 17), saw the redecoration and repositioning of choirs and high altars, as well as the frequent removal of choir or rood screens and choir enclosures, in an attempt to provide the laity with greater visual and physical access to areas of the church which had previously been closed to them.[71] However, the rearrangement of church interiors, such as Giorgio Vasari's regularisation of the naves at both Florence's Santa Maria Novella and Santa Croce in the 1560s, is better understood as a slow and general change of practice linked to local traditions and contemporary politics as much as to wider liturgical reform.[72]

Around the middle of the sixteenth century Vasari recorded having seen an altarpiece by Masaccio in the church of Santa Maria del Carmine in Pisa, the central panel of which is now in the National Gallery (fig. 72). Vasari described the work 'in a chapel of the *tramezzo* [choir or rood screen]', and to judge from his description it had not yet been dismembered, despite the fact that the church was being remodelled at the time. The building work almost certainly involved the removal of the choir screen separating the choir from the nave, and thus the destruction of Ser Giuliano degli Scarsi's chapel, probably positioned against the screen, for which Masaccio's altarpiece had been painted.[73] It is not known exactly when the altarpiece was sliced up, but the panel showing *Saint Paul* (now in the Museo Nazionale di San Matteo, Pisa), which probably came from the same polyptych, was described as a separate picture in 1640 and had already been in another collection by that date. In other words, it had existed as an independent work for some time, suggesting that the remodelling of the church, which was completed around 1574, was the most likely date for the fragmentation of the altarpiece.[74]

Similar generalisations could be made about the replacement of high altarpieces elsewhere. Again, it is important not to attribute these movements to any one particular event. In 1506, around forty years before the Council of Trent met, Duccio's *Maestà* (fig. 27, page 46) was removed from the high altar of Siena Cathedral on the orders of Pandolfo Petrucci, Siena's tyrant, and transferred to a side chapel. The altarpiece had probably already been moved with the high altar, when it was relocated around 1360. Lorenzo Monaco's *San Benedetto Altarpiece* (fig. 9, page 23) was most likely transferred from the high altar of San Benedetto fuori della Porta Pinti to the Alberti Chapel in Santa Maria degli Angeli in 1529, when the monastery was demolished to make way for fortifications during the siege of Florence. In such a case it was not possible

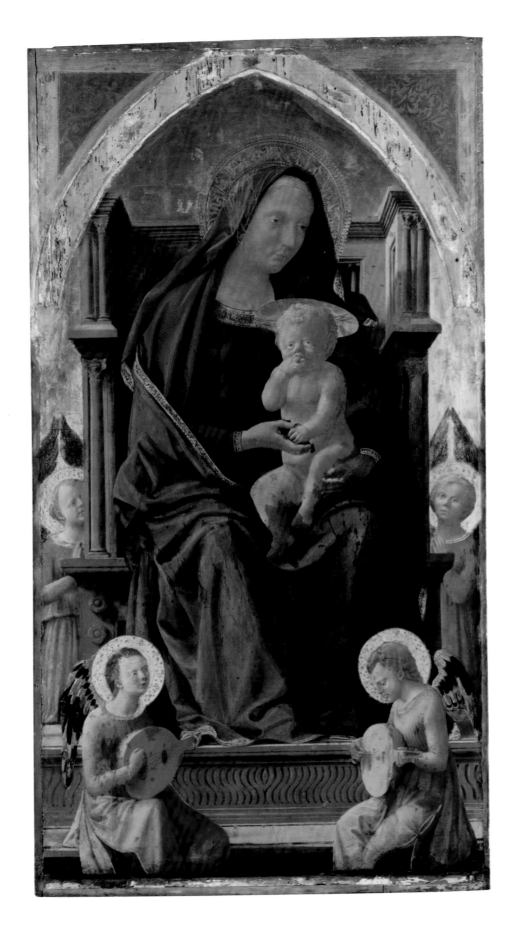

73 Sassetta, *The Wolf of Gubbio*, 1437–44

74 Sassetta, *Saint Francis before the Sultan*, 1437–44

These two panels from Sassetta's *San Sepolcro Altarpiece* suffered the most significant mould damage of the National Gallery's seven panels.

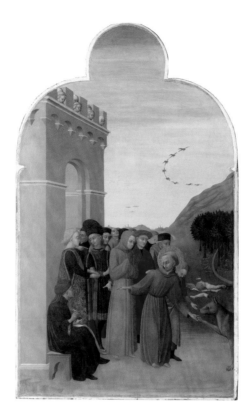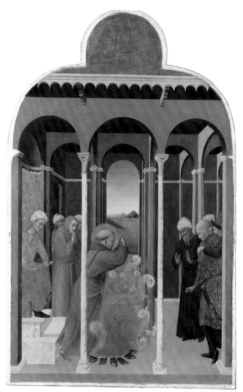

to honour the patron's desire that the altarpiece never be moved from the high altar. The main panel of the altarpiece was apparently damaged during the devastating flood of the river Arno in 1557. The predella, however, was unharmed, suggesting that it had already been separated from the rest of the altarpiece by this date, perhaps to accommodate its new location or because an aperture for a tabernacle was cut into the main panel (an alteration which was patched up some time before the seventeenth century, to judge from an analysis of the pigments used).[75]

Sassetta's *San Sepolcro Altarpiece* was dismantled and removed from the high altar of San Francesco between 1578 and 1583, to be replaced, as was so often the case, by a ciborium. The panels of the polyptych were moved to side altars, where they were recorded by Bishop Angelo Peruzzi during his apostolic visit in 1583.[76] The National Gallery panels, which originally formed part of the back of the altarpiece, were consequently rendered invisible, backed against a humid wall, which left its mark through the mould that grew on *The Wolf of Gubbio* (fig. 73) and *Saint Francis before the Sultan* (fig. 74). However, the panels had not yet been sawn apart: the reuse of the front panels on the side altars of the church was, in all likelihood, achieved by dismantling the frame and separating the panels along their original joins. Presumably some re-framing and carpentry

work was necessary to make them presentable, but surely this involved nothing like the ruthless, commercially motivated slicing undertaken at a later date.

The suppression of religious institutions by regional and national governments across the Italian Peninsula during the second half of the eighteenth century and the early decades of the nineteenth was probably the single greatest peril facing early Italian altarpieces. Pietro Leopoldo, the Grand Duke of Tuscany, for instance, issued an edict of 1775 subjecting 'all the people and goods of the ecclesiastics' to himself and not to Rome, and shortly thereafter reduced or abolished many male and female monasteries. A few years later, in the early 1780s, all companies, confraternities and charitable institutions were dissolved in every parish across the Grand Duchy as part of a wider, 'enlightened' programme of ecclesiastical reforms – reforms which were continued with gusto under Napoleon's governors in Italy. Altarpieces and other works of art were removed from churches, monasteries and oratories.[77] Those which were not transferred to art galleries or storerooms invariably found their way on to the art market at about the same time that the attention of scholars and collectors was turning to the Italian 'primitives'. Indeed, among their number was Luigi Lanzi, a Jesuit who found himself working for the Uffizi after his order was suppressed, and who would go on to publish *La storia pittorica della Italia inferiore* in 1795–6.[78]

Around 1783 the Compagnia della Santissima Trinità, which had commissioned the *Trinity Altarpiece* (fig. 75) from Francesco Pesellino and then Fra Filippo Lippi, was dissolved. Not long afterwards the church of San Jacopo in Pistoia, which had housed the altarpiece, burnt down. How the altarpiece survived or when it was removed from the church is not known, but by the early nineteenth century the main panel had been sawn into five or possibly six pieces and the predella divided into its individual scenes. Given that these different fragments entered English collections soon thereafter, it can be assumed that the altarpiece was divided up in preparation for sale.

Not all fragmentation in the eighteenth century was the result of religious suppression, however. According to a marginal note in the 1776 inventory of Siena Cathedral, Duccio's *Maestà* was 'transported to the last room of the mezzanine of the Rector's quarters to be made into various pictures'.[79] It was cut into seven pieces and separated front from back. Tragically, during this process the carpenter's saw slipped, causing irreparable damage to the Virgin's face. As the eighteenth-century writings of Father Guglielmo della Valle testify, efforts to hail Duccio as the father of Sienese painting both reflected and encouraged a revived interest in the *Maestà*, which was placed over altars in the

75 Francesco Pesellino and (completed by) Fra Filippo Lippi and workshop, *The Pistoia Santa Trinità Altarpiece (Trinity Altarpiece)*, 1455–60

76 A reconstruction showing the original configuration of the predella panels, including *The Vision of Saint Augustine*, now in the State Hermitage Museum, St. Petersburg

77 Detail of fig. 75 showing Saint Jerome and the lion from one of the predella panels

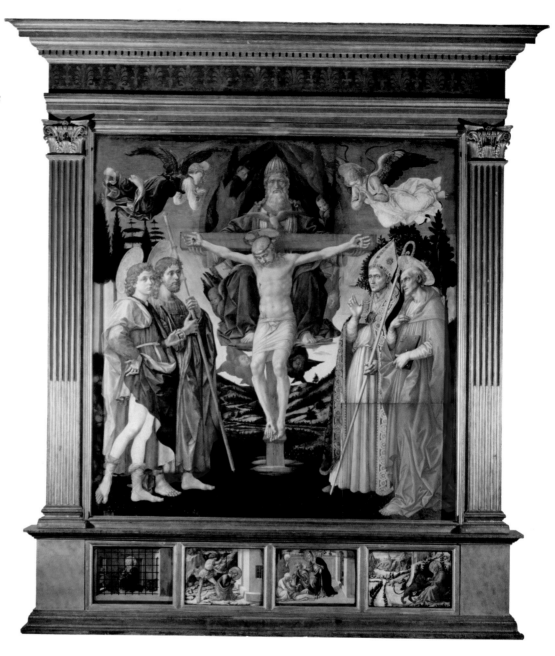

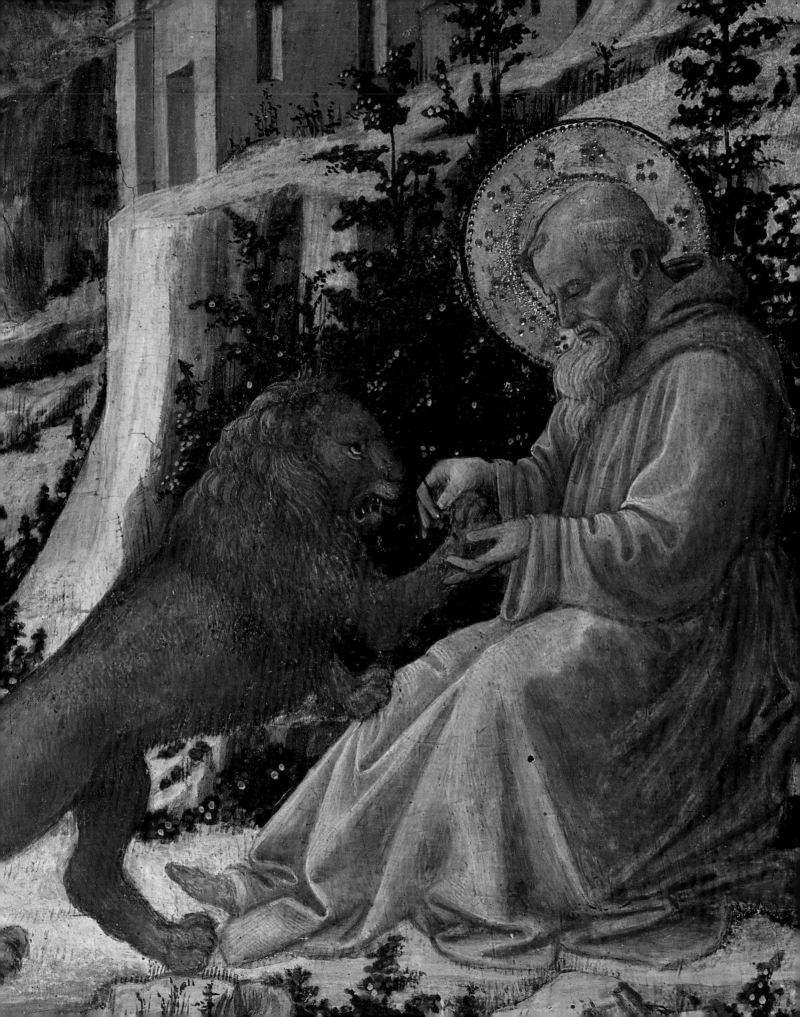

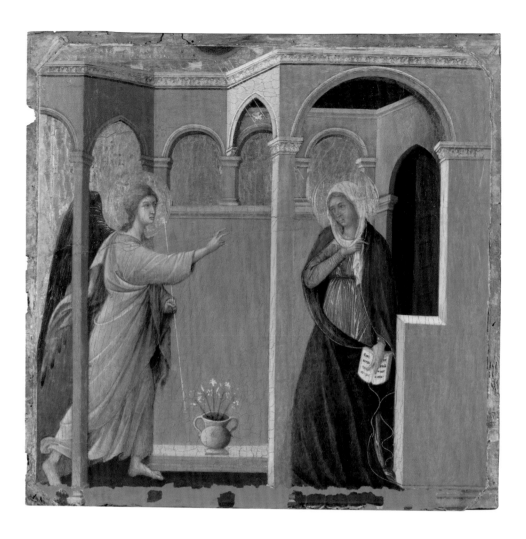

78 Duccio, *The Annunciation*, predella panel from the *Maestà* altarpiece, 1311

cathedral in its new fragmented state, with parts of the predella in the sacristy, where the sacred vessels and vestments were stored. This suggests that the altarpiece had been divided up due to lack of space, not for lack of aesthetic or spiritual appreciation. All the same, by the second half of the nineteenth century, conveniently sized fragments such as *The Annunciation* (fig. 78) from the front predella and *Jesus opens the Eyes of a Man born Blind* (NG 1140) and *The Transfiguration* (NG 1330) from the back predella, had made their way into British collections. These cases reveal that although the market was frequently the driving force behind the dissection of these works, there were also other reasons for such fragmentation. Whatever the initial motivations, from the second quarter of the nineteenth century onwards this practice resulted in an art market flooded with altarpiece fragments.

In 1857 the National Gallery acquired *en bloc* a series of pictures from the collection assembled in Florence by Francesco Lombardi and Ugo Baldi.

79 Niccolò di Pietro Gerini, *Baptism Altarpiece*, 1387, shown here with Giovanni da Milano, *Pinnacle Panels*, about 1365

This is a proposed reconstruction of how the *Baptism Altarpiece* may have looked when sold to the National Gallery in the nineteenth century.

Among them was a polyptych now attributed to Niccolò di Pietro Gerini. This has evidently been altered: the predella has been cut down the middle and presumably had its central scene removed, while the main tier probably originally had two additional full-length saints. The framing elements are a combination of old and new elements, all of which have been re-gilded to give it a more homogeneous appearance. The raised gesso decoration, or *pastiglia*, might be old in some places, but in others has a sharpness which suggests a date in the nineteenth century. It appears therefore that the altarpiece was cut up, probably for sale, and re-assembled at a later date. At some point, three unrelated pinnacles by Giovanni da Milano were added to the structure (fig. 79); these have now been removed and are displayed separately in the Gallery. Given that the frames of both this altarpiece, and the two from Pratovecchio, have been treated in such a similar fashion, and that all were once in the Lombardi Baldi collection, it seems likely that the alterations, or at least the re-assembly, occurred at the same point. The so-called *Demidoff Altarpiece* (fig. 80) underwent a similar procedure, as it was certainly re-composed of most of the panels from two entirely separate altarpieces by Crivelli that were amalgamated in the mid-nineteenth century.

RE-ASSEMBLY

The provenance of fragments and the process by which altarpieces were dismembered were seldom recorded. Art historians have, for over a century, employed different techniques for reconstructing their original forms and identifying missing elements. While connoisseurs such as Bernard Berenson (1865–1959) had to rely upon a combination of their knowledge of artistic style and common sense – and, to a lesser extent, the study of documents – a plethora of different tools are now available to scholars to ascertain whether panels originally derived from the same ensemble. The recent virtual reconstruction of Sassetta's *San Sepolcro Altarpiece* is not only a model of thoroughness, but also an illustration of the sheer volume of resources now at scholars' disposal.[80] Nevertheless, it should be stressed that however scientific, or objective, such tests may seem, they are not infallible and their results still require interpretation, with all the concomitant possibilities for human error: the same data can sometimes give rise to as many reconstructions as there are scholars studying it.

Reconstruction naturally progresses from a thorough understanding of the construction of an altarpiece and those elements that originally held it together.

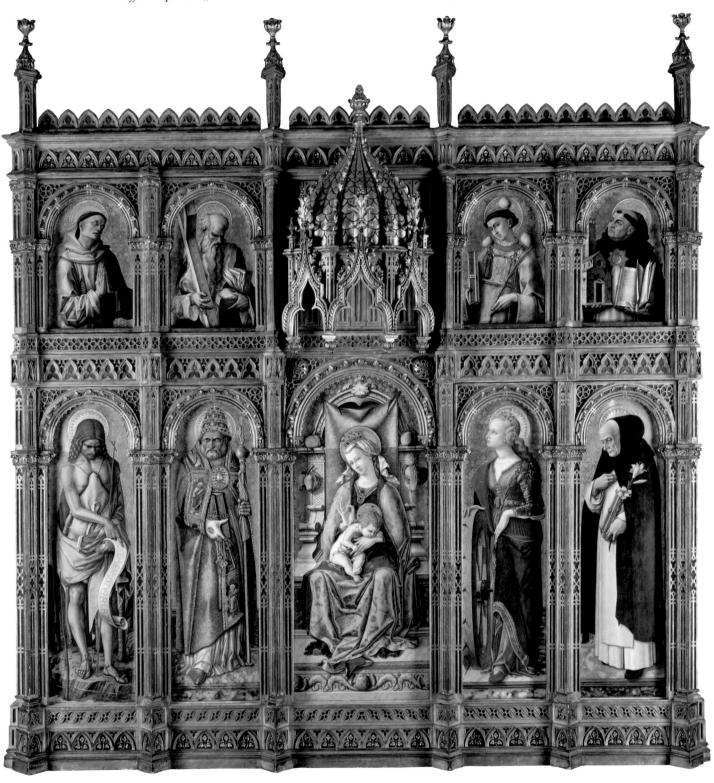

80 Carlo Crivelli, *The Demidoff Altarpiece*, 1476

81 and 82

Sassetta, *San Sepolcro Altarpiece*, 1437–44 (back)

When the huge double-sided panels were sawn down the middle to separate the painted surfaces and create two panels, holes were exposed on the backs of the panels where dowels had once been inserted into the thickness of the wood to reinforce the joins between panels. Before they entered the National Gallery the seven panels now in the collection were thinned further, removing all traces of dowels from the main panels. The upper corners of the panels, which had spandrels with elaborate gilded decoration from the frame attached, were also removed at this time but luckily these were preserved and show evidence of dowel marks in the spandrels.

For example, if the shadow of a batten or the position of the nails that attached a batten to the back of a panel can be established in the same place on the back of several panels, this provides compelling evidence that they were once beside one another. Similarly, the correlation of dowel holes in panels that might have been placed side by side confirms (or negates) an argument for their juxtaposition, as indicated by the discovery of remnants of dowel channels on the back of the lower tier of narrative scenes from Sassetta's *San Sepolcro Altarpiece* (figs 81 and 82).[81]

83 Attributed to the Master
of the Pala Sforzesca,
Saint Paul, about 1495

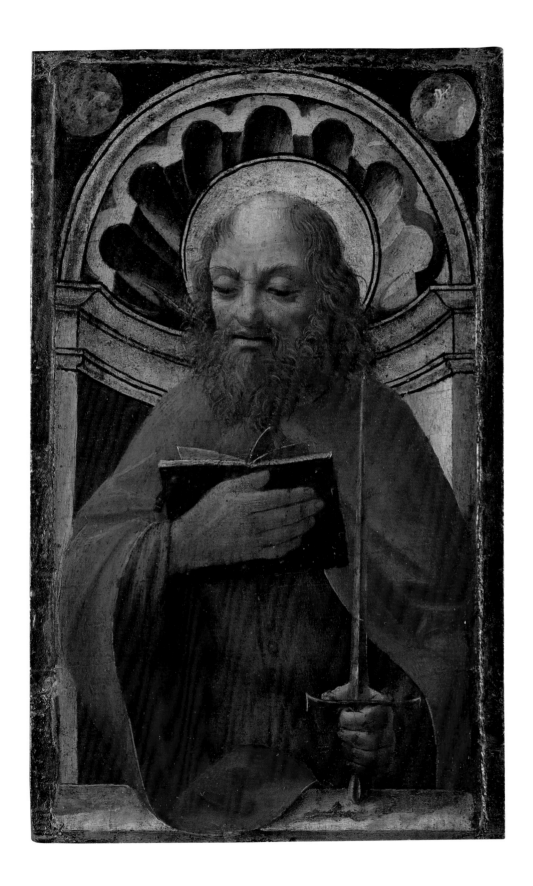

The study of wood grain is also a useful aid when there is the suspicion that a single plank has been cut. In such cases, the backs of two panels may be compared or, more frequently, X-radiography used to examine wood grain; this has the advantage of allowing comparison between two panels in different collections. In the case of a predella, the grain customarily runs horizontally, in contrast to the vertical grain of the pilasters which flank both the upper tiers and the predella itself. Thus, although Lorenzo Monaco's *The Baptism of Christ* (fig. 87, page 114) and the Master of the Pala Sforzesca's *Saint Paul* (fig. 83) are ostensibly similar and are roughly the same size, the fact that the former has a wood grain running vertically and the latter horizontally suggests that they came from different parts of an altarpiece. Furthermore, *Saint Paul* is painted on walnut, a wood characteristically used by the early Milanese followers of Leonardo. In this case, the painted panel has been backed onto another piece of timber so that the direction of the grain can only be seen from the sides (an X-ray would also show up the grain of the new timber on the back). Thus it would seem likely that *Saint Paul* was part of a predella – possibly a row of saints or one of several saints interspersed between narrative scenes – while *The Baptism of Christ* was the base of a lateral pier. However, the *Baptism* would probably have been at the same height as the predella and so would have been seen in conjunction with it (in terms of narrative), despite being structurally part of another element.

In some cases, this system of construction continued even once the lateral piers had been abandoned in favour of the *all'antica* tabernacle frame. The predella of Crivelli's *The Madonna of the Swallow* (fig. 56, page 83), for example, is formed of a single plank with the grain running horizontally, to which two panels with a vertical grain have been fixed, painted with the images of Saint Catherine and Saint George respectively. In this context it is significant that Crivelli painted both polyptychs and *pale*, and so – assuming that he instructed the carpenter himself – the techniques of one type might have been adopted for the other.

This understanding is especially useful when reconstructing predelle and pilasters, which were generally made of a single panel although not always a single plank; the predella of Niccolò di Pietro Gerini's *Baptism Altarpiece* (fig. 79, page 105), for example, has a narrower plank glued along the bottom. Sometimes the examination of wood grain throws up surprising results. In the case of three fragments by the Master of the Castello Nativity – including the National Gallery *Nativity* and the two panels in the Philadelphia Museum of Art showing *Saint Justus and Saint Clement praying for Deliverance from*

84 Piero della Francesca, *Misericordia Altarpiece*, about 1448
Tempera on panel, 273 x 323 cm
Pinacoteca Comunale, Sansepolcro

This image shows the altarpiece as it is currently displayed, although recent research has demonstrated that the predella panels were originally in a different order.

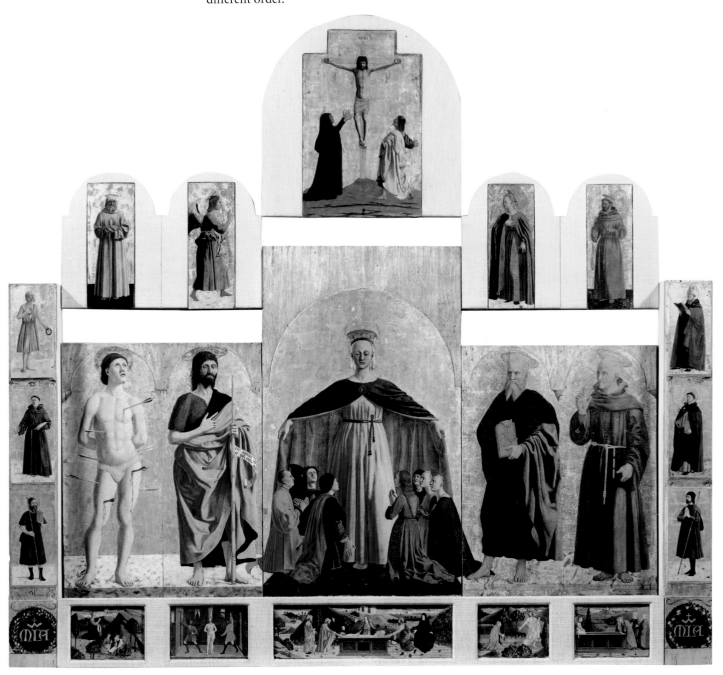

Barbarians and *Saint Justus and Saint Clement multiplying the Grain of Volterra* – this has not only confirmed that they all come from the same predella, but that they appear in reverse chronological order if 'read' from left to right.[82] Recent analysis of the predella of Piero della Francesca's dismantled polyptych for the Confraternity of the Misericordia in Borgo San Sepolcro (fig. 84), painted on a single plank that was subsequently divided, has shown that the scenes were originally arranged, from left to right: *The Three Marys at the Tomb, Noli me tangere, The Entombment, The Flagellation* and finally *The Agony in the Garden*. Consequently the narrative did not run chronologically here either. Instead, it read inwards from the right (*The Agony in the Garden* to the *The Flagellation*), then downwards from the top (*The Crucifixion* in the central pinnacle to *The Entombment* in the predella) and then inwards from the left (*The Three Marys* to *Noli me tangere*).[83] This sense of movement from the edge to the centre, whether from the sides inwards, or top downwards, was no doubt designed to focus attention on the celebrant of the Mass standing before the altar.

Predelle might, of course, be reconstructed using different means. For example, while the visible discontinuity in the wood grain of the predella of Pesellino's *Trinity Altarpiece* (fig. 75, page 102) indicated that a central scene was missing, its identification on the basis of subject-matter with the panel in the State Hermitage Museum in St Petersburg was only confirmed by correlations in height and similarities of technical features, such as underdrawn horizontal lines across the top and bottom of the panels that are visible to the naked eye and in infrared light.

On gold ground paintings it is also possible to draw conclusions by comparing punchmarks or incisions in the background. The punched border pattern of Lorenzo Monaco's *The Baptism of Christ* (figs 87 and 88), for example, matches that of two predella panels that may have come from the same altarpiece (figs 89 and 90). Similar points could be made about the incisions that define the haloes of the half-length saints believed to have originally formed the upper tier of Marco Zoppo's polyptych for the high altar of Santa Giustina in Venice (figs 85 and 86).[84] More recently, an altarpiece attributed to Jacopo di Cione has been reconstructed, partially on the evidence of punchmarks. The same punched border pattern is shared by the *Noli me tangere* in the National Gallery (NG 3894), a *Crucifixion* in the Lehman Collection at the Metropolitan Museum of Art, New York, a *Pietà* in Denver, as well as the *Six Angels* also in the Lehman Collection and the pilaster saints, some of which are on loan to the National Gallery from the Church of Saint Mary Magdalene, Littleton, Middlesex. What is more, Christ's halo is identical in the first three of these

85 Marco Zoppo, *A Bishop Saint, perhaps Saint Augustine*, probably about 1468

86 Marco Zoppo, *Saint Paul*, probably about 1468
Tempera and gilding on panel, 49.5 x 31 cm
Ashmolean Museum, Oxford

87 Attributed to Lorenzo Monaco, *The Baptism of Christ*, 1387–8

88 Detail of punchmarks in fig. 87

89 Lorenzo Monaco, *Saint James and Sorcerer Hermogenes, and Beheading of Saint James*, predella from the *Nobili Altarpiece, Santa Maria degli Angeli, Florence*, 1387 Tempera on panel, 34 x 67 cm Musée du Louvre, Paris

90 Detail of punchmarks in fig. 89

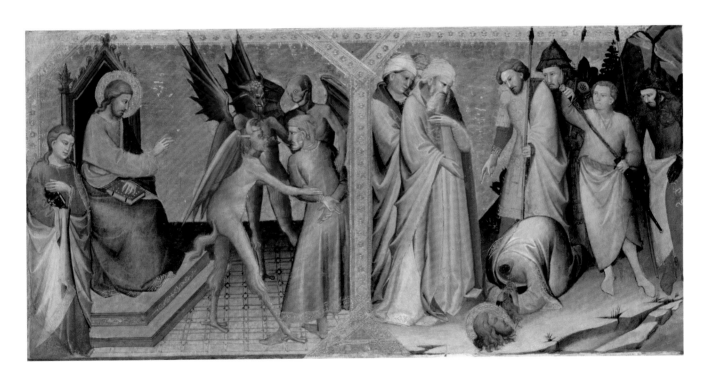

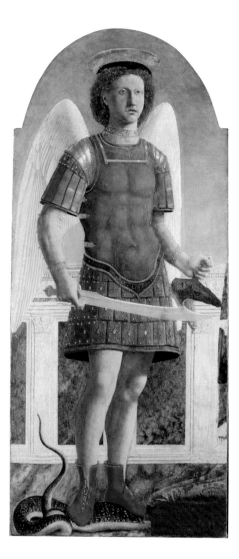

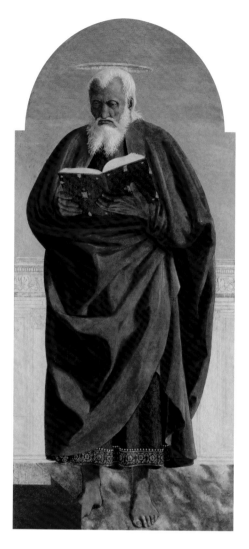

91 Piero della Francesca,
Saint Michael,
completed 1469

92 Piero della Francesca,
Saint John the Evangelist,
completed 1469
Tempera on panel,
134 x 62.2 cm
The Frick Collection,
New York

panels. This rosette punchmark is found in panels painted by all three of the
Cione brothers and is thus a useful attributional aid, even if tools such as
punches were sometimes used by more than one workshop.

These are just a few of the most common techniques employed in
reconstructing altarpieces. In certain instances, evidence of style, composition
and subject matter is often enough to establish that fragments came from the
same structure. The panels by Piero della Francesca showing *Saint Michael*
(fig. 91), *Saint Augustine* (Museu Nacional de Arte Antiga, Lisbon), *Saint John
the Evangelist* (fig. 92) and *Saint Nicholas of Tolentino* (Museo Poldi Pezzoli,
Milan) are all of the same size and shape, and, more importantly, all have the
same painted background of marble panels divided by Corinthian pilasters
beneath a frieze with Greek foliate (anthemion) decoration, which establish
beyond doubt that they all came from the same altarpiece, that of Sant'Agostino

93 Attributed to Fra
Angelico, *Saint Romulus*
from *Fiesole San
Domenico Altarpiece*,
about 1423–4

in Borgo San Sepolcro. Furthermore, while it is known from sixteenth- and
nineteenth-century descriptions that the central panel, now lost, originally
represented the Virgin, the remnants of a step visible at the edges of the London
and New York panels (and an additional cloth in the London panel) would have
suggested her original inclusion, seated on a throne.

In other cases, the evidence of iconography is the overriding factor in
identifying elements of an altarpiece. For example, the relationship between two
roundel fragments by Fra Angelico showing saints – one in the National Gallery
(fig. 93), the other in the Metropolitan Museum of Art, New York – was argued
on visual evidence long ago. The similarity of style, form and punching all
suggested that they were derived from the same altarpiece. It was only when they
were recognised as Saint Romulus and Saint Alexander, the respective dedicatees
of the Cathedral and a neighbouring church in Fiesole, that a convincing

argument was made suggesting that they had once been part of Fra Angelico's high altarpiece for San Domenico in the same diocese.[85]

Recently another technique was used to corroborate this evidence. The threads of the canvas, which formed an intermediary surface between the timber support and the gesso, were X-rayed, then magnified and counted. The same number of horizontal to vertical threads per square centimetre were found on the predella (which is undoubtedly from San Domenico) and *Saint Romulus*, suggesting that the same roll of canvas was used to line both panels. However, as with many of the techniques outlined above, the result of the thread count is insufficient to prove that they came from the same altarpiece; it is only when added to iconographic and stylistic evidence that the argument achieves a critical – and highly credible – weight.

RELICS

These dismembered altarpieces have an importance to us that would have seemed puzzling to their first viewers: the fragments that had meaning for them were of an entirely different nature.

At the height of summer 1308, the Augustinian nuns of Montefalco dissected the recently deceased body of their abbess, Chiara, which had shown no signs of decomposing despite the August heat. Sister Francesca of Montefalco cut her open from the back and, with Sisters Francesca of Foligno, Illuminata, Marina and Elena, they removed her entrails and heart, which they placed in a box. They then embalmed the body. The following evening, after vespers, they examined the heart again, slicing into it and finding a crucifix. The process was repeated once again on her heart and then her gall bladder. Each time, her dislocated organs provided further evidence of her sanctity.[86] A few years later Margarita of Città di Castello was subjected to a similar process of 'fragmentation'. There was nothing unusual in this. Saints – or at least individuals suspected of being saints – were regularly dismembered and their body parts preserved in reliquaries. The sight of bodily fragments to late medieval and Renaissance viewers was proof of their holiness. By the same token, the sight of dismembered, fragmented and cut-up altarpieces is to us testament to their artistic value. We travel to museums to venerate and admire these fragments of altarpieces – present-day relics – in much the same way as Chiara's dislocated heart can still be venerated, separate from her uncorrupted body in Montefalco.

NOTES

All references to National Gallery paintings are indebted to the research and catalogues of Dillian Gordon and Martin Davies, who are acknowledged here to avoid repetition in the notes below. See D. Gordon, *National Gallery Catalogues: The Fifteenth Century Italian Paintings*, vol. 1, London 2003; D. Gordon, *National Gallery Catalogues: The Italian Paintings before 1400*, London 2011; and M. Davies, *National Gallery Catalogues: The Earlier Italian Schools*, London 1961.

1 Humfrey 1993, p. 12; Gardner 1994, p. 14.
2 Amery 1991, pp. 72, 79.
3 Dabell 1984, pp. 86–8, doc. 9; see also De Marchi 2002.
4 Humfrey 1993, pp. 34–7, 320 n. 30.
5 For the objects associated with the altar, see Van Os 1984–90, p. 12; Gauthier 1978, p. 37. For this definition of the liturgy, see Williamson 2004, p. 343.
6 For a useful introduction to the liturgy and its various texts, see Vogel 1986; Heffernan and Matter 2001.
7 Much of the following section is indebted to Gardner 1994.
8 Limentani Virdis and Pietrogiovanna 2002, p. 14.
9 Innocent III, Sermon 28, 'In consecratione altaris …', cited in Kloft 2006, p. 27.
10 Michel Andrieu cited in Kloft 2006, p. 27.
11 Williamson 2004, pp. 354–6.
12 Wilkins 1978, p. 148, fig. 23.
13 Trans. D. Cooper and J. Banker, 'The Church of San Francesco in Borgo San Sepolcro in the Late Middle Ages and Renaissance', in Israëls 2009, p. 58.
14 C. Gardner von Teuffel, 'Sassetta's Franciscan Altarpiece at Borgo San Sepolcro: Precedents and Context', in Israëls 2009, p. 214.
15 On the function of altarpieces as 'labels', see Baxandall 1980, p. 64.
16 Braun 1924, vol. 2, p. 281.
17 Lotario Conti (later Pope Innocent III), *De Sacro Altaris Mysterio*, as cited by Gardner 1994, p. 7 and n. 9. For a discussion of this text under its correct title, *De missarum misteriis*, see M. Maccarone, 'Innocenzo III teologo dell'Eucaristia', *Divinitas*, 10 (1966), pp. 362–412.

18 Israëls 2008, pp. 130, 180 n. 43; trans. Gordon *National Gallery Catalogues: The Italian Paintings before 1400*, 'Duccio', n. 63.
19 Ahl 2000, pp. 48, 67 n. 16. For more on the Confraternity of the Purification and of Saint Zenobius and their altarpiece, see p. 30. The ciborium in this context is a vessel containing the consecrated host.
20 Beck 1978, pp. 46–7, appendix doc. 12, items 3 and 4; see also Gordon 2003, p. 216.
21 Ahl 2000, p. 70 n. 81.
22 Nova 1994, pp. 179–80, citing Durand 2007 edn; Schmidt 2007, pp. 191–213.
23 Kees van der Ploeg, 'How Liturgical Is a Medieval Altarpiece?', in Schmidt 2002, pp. 103–21.
24 Lightbown 2004, p. 478.
25 Vigri 1985, pp. 78–81.
26 Van Os 1984–90, vol. 1, p. 152, nn. 102–3.
27 Kloft 2006, p. 24.
28 For a succinct summary of the various arguments, see Williamson 2004, especially pp. 343–8.
29 Gardner 1994, p. 6.
30 Gardner 1994, p. 13 and n. 46 for further bibliography. On the celebration of the Mass 'facing east', especially in the Roman basilicas, see Strehlke 2004, p. 259, with further bibliography.
31 Kloft 2006, p. 26.
32 Joanna Cannon has discussed the vertical axis of an altarpiece with the Man of Sorrows above the altar, with God the Father and the Virgin and Child. The suggestion made here builds on her argument: see Cannon 1982, p. 73. See also Rosand 1990, p. 144.
33 Ahl 2000, p. 52.
34 Radke 2001.
35 Cooper 2001, p. 8.
36 Bagemihl 1996.
37 Marin Sanudo, cited in Shearman 2003, pp. 171–2.
38 Williamson 2004.
39 Hills 1990.
40 On the false division between public and private in terms of liturgy and devotion, see Williamson 2004, p. 380.

41 Gordon 2009.

42 Cannon 1994, pp. 41–79.

43 There is an extensive literature of the contractural phrase *modo et forma*; see O'Malley 2005b, pp. 221–50, for a recent discussion with full bibliography.

44 Neri di Bicci 1976, pp. 32–3.

45 For the debate on the first Florentine *pala*, see Hood 1993, p. 107.

46 Gardner von Teuffel 2005, pp. 209–10.

47 On the 1434 document for San Lorenzo, see Ruda 1978 and Saalman 1978.

48 Teza 2003.

49 Van Os 1984–90, vol. 2, pp. 53–9.

50 Humfrey 1993.

51 This chapter is heavily dependent on the research of Christa Gardner von Teuffel, who is acknowledged here to avoid excessive repetition; see Gardner von Teuffel 2005, pp. 119–81, 183–210.

52 Stubblebine 1979, vol. 1, pp. 34–5; see also Van Os 1984–90, p. 39.

53 On the term *sacra conversazione*, see Goffen 1979 and Humfrey 1993, pp. 12–13.

54 Hirst 1981, p. 590.

55 Gardner von Teuffel 2005, pp. 119–82.

56 Cadogan 2000, cat. 34, pp. 259–61.

57 See Smith *et al.* 1989.

58 On the network of altarpieces commissioned and 'copied' in Borgo San Sepolcro, see Israëls 2009, *passim*.

59 Much of the following section is indebted to Venturini 1994, pp. 84, 130–1, cat. 87; and Lillie 2007.

60 Pope-Hennessy 1964, p. 182.

61 The following section is indebted to the research of Lightbown 2004, pp. 473–87.

62 For the contract, see Zampetti 1986, pp. 17, 296–8.

63 On artists' signatures and self-fashioning, see Rubin 2006.

64 The *Altarpiece of the Purification* has been extensively discussed by Diane Cole Ahl; see Ahl 1996, pp. 112–19, 224–6, 277–8; Ahl 2000.

65 Quoted in Ahl 2000, pp. 60–1. For a full English translation of the contract, see Chambers 1970, pp. 52–5.

66 Nicholas Penny as recorded in Ahl 2000, p. 72 n. 106.

67 Hood 1993, pp. 195–207.

68 For a discussion of the issue of agency in this altarpiece, which draws on the anthropological theory of art and agency by Alfred Gell, see O'Malley 2005a.

69 National Gallery Archive, NG1/5 Board Minutes 1 May 1882.

70 I am grateful to Joanna Cannon for this suggestion.

71 Hall 1979.

72 Cooper 2001.

73 Opinions are divided on this subject: see Gardner von Teuffel 2005, pp. 1–71; Gordon 2003, pp. 209–16.

74 Gordon 2003, pp. 209, 221 n. 17.

75 Gordon 2003, pp. 172–7.

76 Israëls 2009, vol. 2, appendix doc. XXXVIII, pp. 577–9.

77 For a useful introduction to the ecclesiastical reforms of Pietro Leopoldo during the second half of the eighteenth century in Tuscany, see Verga 2000, with further bibliography.

78 Strehlke 2001.

79 Stubblebine 1979, pp. 35–6.

80 Israëls 2009.

81 Israëls 2009, p. 180 and cats 15, 16, 19, 20.

82 Gordon 2003, pp. 250–1 (fig. 5 on p. 252 is reversed); Strehlke 2004, pp. 278–9, especially n. 2.

83 Roberto Bellucci, Ciro Castelli, Ottavio Ciappi and Cecilia Frosinini cited in Israëls 2009, p. 175.

84 Humfrey 1993, p. 343, cat. 11.

85 Gardner von Teuffel 2005, pp. 364–71.

86 Menestò 1984, p. 339; see also Park 1994, pp. 1–3.

BIBLIOGRAPHY

Ahl, D.C., *Benozzo Gozzoli*, New Haven and London, 1996
———, '"In corpo di compagnia": Art and Devotion in
the Compania della Purificazione e di San Zanobi
of Florence', in *Confraternities and the Visual Arts in
Renaissance Italy: Ritual, Spectacle, Image*, ed. D.C.
Ahl and B. Wisch, Cambridge 2000, pp. 46–73

Amery, C., *The National Gallery Sainsbury Wing: A
Celebration of Art & Architecture*, London 1991

Bagemihl, R., 'Francesco Botticini's Palmieri Altarpiece',
Burlington Magazine, 138, no. 1118 (1996), pp. 308–14

Baxandall, M., *The Limewood Sculptors of Renaissance
Germany*, New Haven and London 1980

Beck, J.H., *Masaccio, the Documents*, Locust Valley, NY, 1978

Borsook, E., and F. Superbi Gioffredi (eds), *Italian
Altarpieces 1250–1500: Function and Design*,
Oxford 1994

Braun, J.B., *Der christlicher Altar in seiner geschichtlichen
Entwicklung*, 2 vols, Munich 1924

Cadogan, J.K., *Domenico Ghirlandaio: Artist and Artisan*,
New Haven and London 2000

Cannon, J., 'The Creation, Meaning, and Audience of the
Early Sienese Polyptych: Evidence of the Friars', in
Italian Altarpieces 1250–1500: Function and Design, ed.
E. Borsook and F. Superbi Gioffredi, Oxford 1994,
pp. 41–80

———, 'Simone Martini, the Dominicans and the Early
Sienese Polyptych', *Journal of the Warburg and
Courtauld Institutes*, 45 (1982), pp. 69–93

Chambers, D.S., *Patrons and Artists in the Italian
Renaissance*, London 1970

Cooper, D., 'Franciscan Choir Enclosures and the Function
of Double-Side Altarpieces in Pre-Tridentine
Umbria', *Journal of the Warburg and Courtauld
Institutes*, 64 (2001), pp. 1–54

Dabell, F., 'Antonio d'Anghiari e gli inizi di Piero della
Francesca', *Paragone*, 35, no. 417 (1984), pp. 73–94

Davies, M., *National Gallery Catalogues: The Earlier Italian
Schools*, London 1961

De Marchi, A., 'Matteo di Giovanni ai suoi esordi e il
politico di San Giovanni in Val d'Afra', in *Matteo di
Giovanni e la pala d'altare nel senese e nell'aretino,
1450–1500*, eds D. Gasparotto and S. Magnani,
Montepulciano 2002, pp. 57–75

Durand, G., *The rationale divinorum officiorum of William
Durand of Mende: A new translation of the prologue
and book one*, New York 2007

Gardner, J., 'Altars, Altarpieces, and Art History: Legislation
and Usage', in *Italian Altarpieces 1250–1500: Function
and Design*, ed. E. Borsook and F. Superbi Gioffredi,
Oxford 1994, pp. 5–40

Gardner von Teuffel, C., *From Duccio's Maestà to Raphael's
Transfiguration: Italian Altarpieces and their Setting*,
London 2005

Gauthier, M.-M., 'Du tabernacle au retable: Une innovation
limousine vers 1230', *Revue de l'art*, 40–1 (1978),
pp. 23–42

Goffen, R., 'Nostra Conversatio in Caelis Est: Observations
on the *Sacra Conversazione* in the Trecento', *Art
Bulletin*, 61, no. 2 (1979), pp. 198–222

Gordon, D., *National Gallery Catalogues: The Fifteenth
Century Italian Paintings*, vol. 1, London 2003

———, 'Andrea di Bonaiuto's Painting in the National
Gallery and S. Maria Novella: The Memory of a
Church', *Burlington Magazine*, 151 (2009), pp. 512–18

———, *National Gallery Catalogues: The Italian Paintings
before 1400*, London 2011

Hall, M., *Renovation and Counter-Reformation: Vasari and
Duke Cosimo in Sta Maria Novella and Sta Croce
1565–1577*, Oxford 1979

Heffernan, T.J., and E.A. Matter (eds), *The Liturgy of the
Medieval Church*, Kalamazoo 2001

Hills, P., 'The Renaissance Altarpiece: A Valid Category', in
The Altarpiece in the Renaissance, ed. P. Humfrey and
M. Kemp, Cambridge 1990, pp. 34–48

Hirst, M., 'Michelangelo in Rome: An Altarpiece and the
"Bacchus"', *Burlington Magazine*, 123 (1981),
pp. 581-93.

Hoeniger, C., *The Restoration of Paintings in Tuscany
1250–1500*, Cambridge 1995

Hood, W., *Fra Angelico at San Marco*, New Haven and
London 1993

Humfrey, P., *The Altarpiece in Renaissance Venice*, New
Haven and London 1993

Israëls, M., 'An angel at Huis Bergh: clues to the structure
and function of Duccio's "Maestà"', in *Voyages of
discovery in the collections of Huis Bergh*, ed.
A. de Vries, s'Heerenberg 2008, pp. 122–33, 176–80

———, (ed.), *Sassetta: The Borgo San Sepolcro Altarpiece*, 2
vols, Leiden 2009

Kloft, M., 'Skizzen zum mittelalterlichen Altar in Italien im
Spiegel von Liturgie und Recht / Sketches on the
Medieval Altar in Italy as Reflected in the Liturgy and

the Law', in *Kult Bild. Das Altar- und Andachtsbild von Duccio bis Perugino. Cult Image – Altarpiece and Devotional Painting from Duccio to Perugino*, ed. J. Sander, exh. cat., Städel Museum, Frankfurt am Main, 2006, pp. 23–30

Laclotte, M., *Polyptyques: Le tableau multiple du moyen âge au vingtième siècle*, exh. cat. Musée du Louvre, Paris,

Lightbown, R., *Carlo Crivelli*, New Haven and London, 2004

Lillie, A., 'Fiesole: Locus amoenus or Penitential Landscape?' *I Tatti Studies*, 11 (2007), pp. 11–55

Limentani Virdis, C., and M. Pietrogiovanna, *Gothic and Renaissance Altarpieces*, London 2002

Maccarone, M., 'Innocenzo III teologo dell'Eucaristia', *Divinitas*, 10 (1966), pp. 362–412

Menestò, E. (ed.), *Il processo di canonizzazione di Chiara da Montefalco*. Scandicci 1984

Neri di Bicci, *Le Ricordanze (10 marzo 1453–24 aprile 1475)*, ed. B. Santi, Pisa 1976

Nova, A., 'Hangings, Curtains, and Shutters of Sixteenth-Century Lombard Altarpieces', in *Italian Altarpieces 1250–1500: Function and Design*, eds E. Borsook and F. Superbi Gioffredi, Oxford 1994, pp. 177–200

O'Malley, M., 'Altarpieces and Agency: The Altarpiece of the Society of the Purification and its "Invisible Skein of Relations"', *Art History*, 28, no. 4 (2005), pp. 417–41

——, *The Business of Art: Contracts and the Commissioning Process in Renaissance Italy*, New Haven and London 2005

Park, K., 'The Criminal and the Saintly Body: Autopsy and Dissection in Renaissance Italy', *Renaissance Quarterly*, 47, no. 1 (1994), pp. 1–33

Pope-Hennessy, J., *Catalogue of Italian Sculpture in the Victoria and Albert Museum*, 3 vols, London 1964

Radke, G.M., 'Nuns and Their Art: The Case of San Zaccaria in Renaissance Venice', *Renaissance Quarterly*, 54, no. 2 (2001), pp. 430–59

Rosand, D., '"Divinità di cosa dipinta": Pictorial Structure and the Legibility of the Altarpiece', in *The Altarpiece in the Renaissance*, ed. P. Humfrey and M. Kemp, Cambridge 1990, pp. 143–64

Rubin, P. L., 'Signposts of Invention: Artists' Signatures in Italian Renaissance Art', *Art History*, 29, no. 4 (2006), pp. 563–99

Ruda, J., 'A 1434 Building Programme for San Lorenzo in Florence', *Burlington Magazine*, 120, no. 903 (1978), pp. 358–61

Saalman, H., 'San Lorenzo: The 1434 Chapel Project', *Burlington Magazine*, 120, no. 903 (1978), pp. 360–4

Schmidt, V.M. (ed.), *Italian panel painting in the Duecento and Trecento*, Washington, DC, New Haven and London 2002

——, 'Curtains, Revelatio and Pictorial Reality', in *Wearing, Veiling and Dressing: Textiles and their Metaphors in the Late Middle Ages*, eds K.M. Rudy and B. Baert, Brepols 2007, pp. 191–213

Shearman, J., *Raphael in Early Modern Sources (1483–1602)*, New Haven and London 2003

Smith, A., *et al.*, 'An Altarpiece and its Frame: Carlo Crivelli's "Madonna della Rondine"', *National Gallery Technical Bulletin*, 13 (1989), pp. 29–43

Strehlke, C.B., 'Carpentry and Connoisseurship: The Disassembly of Altarpieces and the Rise of Interest in Early Italian Art', in *Rediscovering Fra Angelico: A Fragmentary History*, ed. C. Dean, exh., cat. Yale University Art Gallery 2001, pp. 41–58

——, *Italian Paintings 1250–1450 in the John G. Johnson Collection and the Philadelphia Museum of Art*, Philadelphia 2004

Stubblebine, J.H., *Duccio di Buoninsegna and His School*, 2 vols, Princeton 1979

Teza, L., *Per Fiorenzo di Lorenzo, pittore e scultore: Una proposta di ricomposizione della nicchia di San Francesco al Prato a Perugia e altre novità*, Perugia 2003

Van Os, H., *Sienese Altarpieces, 1215–1460*, 2 vols, Groningen 1984–90

Venturini, L., *Francesco Botticini*, Florence 1994

Verga, M., 'Le riforme ecclesiastiche di Pietro Leopoldo', in *Le riforme di Pietro Leopoldo e la nascita della Toscana moderna*, ed. V. Baldacci, Florence 2000, pp. 61–70

Vigri, S.C., *Le sette armi spirituali*, ed. C. Foletti, Padua 1985

Vogel, C., *Medieval Liturgy: An Introduction to the Sources*, trans. W.G. Storey and N. Krogh Rasmussen, Washington, DC, 1986.

Wilkins, D., 'Early Florentine Frescoes in Santa Maria Novella', *Art Quarterly*, n.s. 1, no. 3, (1978), pp. 141–74

Williamson, B., 'Altarpieces, Liturgy, and Devotion', *Speculum*, 79, no. 2 (2004), pp. 241–406

Zampetti, P., *Carlo Crivelli*, Florence, 1986

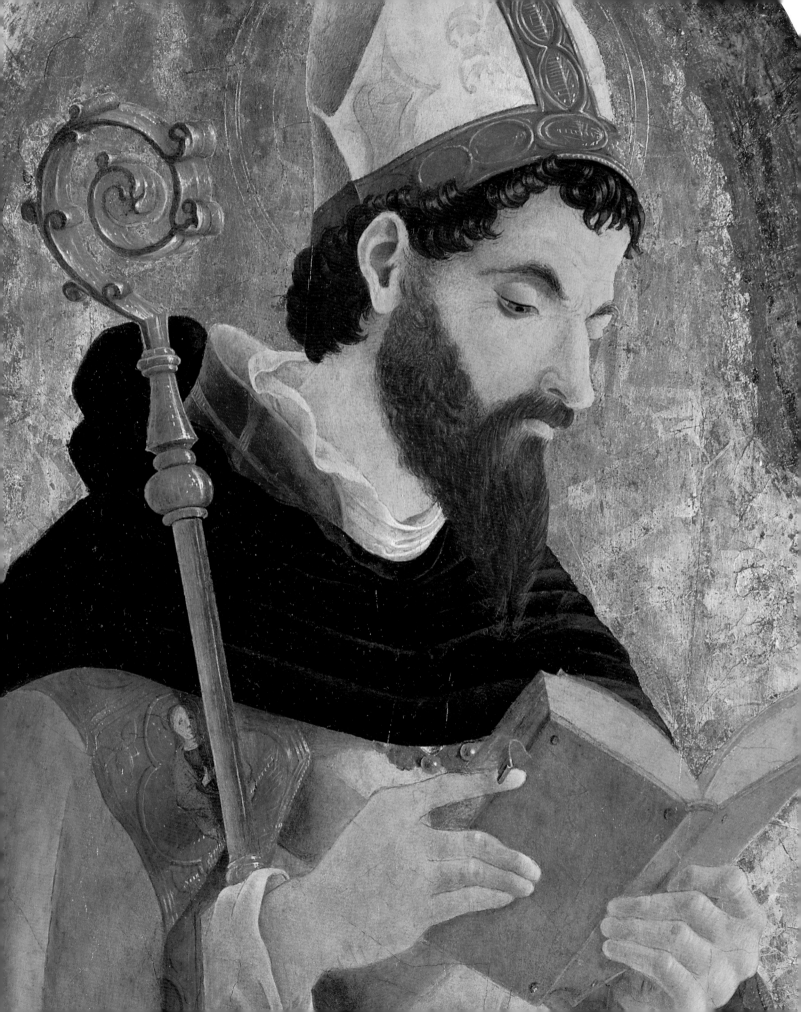

GLOSSARY

ALTAR

Consecrated table at which Mass is celebrated; an altarpiece may be placed on top of or abutting it.

CIBORIUM

A vessel with a cover or cage-like construction used to hold the Eucharist. On certain occasions, and at certain dates, it might refer to a canopy over the altar.

DOWEL

A spindle-shaped piece of wood inserted into holes across a join to align planks of wood and reinforce the join.

EUCHARIST

Christian sacrament commemorating the Last Supper by consecrating and sharing bread and wine.

GESSO

The Italian term for gypsum, the material used for the ground (a preparatory layer) for tempera painting on panel.

LITURGY

The formal rites of the Christian Church.

MASS

Church service commemorating the sacrifice of Christ with the celebration of the Eucharist.

PALA (PL. PALE)

A single-field altarpiece usually with a rectangular, unified painted surface and a classicising frame. A *pala all'antica* is one inspired by antique motifs.

PINNACLE

Topmost panel(s) of a multi-tiered altarpiece.

POLYPTYCH

A multi-panelled altarpiece.

PREDELLA (PL. PREDELLE)

The horizontal base of an altarpiece often decorated with narrative images related to the saints depicted in the altarpiece above.

PUNCH

Cylindrical metal tool with a decorative motif cut into one end. A hammer is used to strike the other end and impress the motif into gilded gesso.

PYX

A container in which wafers for the Eucharist are kept.

RELIQUARY

Container for relics – that is, the physical remains of saints or other religious figures, such as bones, pieces of clothing or some object associated with them.

ROOD SCREEN

Screen across a church dividing the choir, clerical or conventual sanctuary and the congregational space in the nave of a church. Altars were sometimes placed against it. The word derives from the Saxon and would not have been used in late medieval or Renaissance Italy.

LIST OF WORKS

Andrea di Bonaiuto da Firenze,
The Virgin and Child with Ten Saints,
about 1365–70
Tempera on wood, 28 x 105.8 cm
NG 5115

Fra Angelico, *Blessing Redeemer*,
about 1423
Tempera on wood, 28 x 22 cm
L10
On loan from Her Majesty the Queen

Attributed to Fra Angelico,
Saint Romulus from *Fiesole San
Domenico Altarpiece*, about 1423–4
Egg tempera on wood, 16 x 15.6 cm
NG 2908

Benozzo Gozzoli, *Saint Peter and the
Fall of Simon Magus*, 1461
Tempera on panel, 24.3 x 34.5 cm
X7233
Lent by Her Majesty the Queen

Benozzo Gozzoli, *The Virgin and
Child enthroned among Angels and
Saints*, 1461–2
Tempera on wood, 161.9 x 170.2 cm
NG 283

Francesco Botticini, *San Gerolamo
Altarpiece*, about 1490
Tempera on poplar?, 235 x 258 cm
NG 227.1–NG 227.2

Attributed to Francesco Botticini,
The Crucifixion, about 1471
Tempera on wood, 28.5 x 35 cm
NG 1138

Attributed to Bernardino Butinone,
The Adoration of the Shepherds,
about 1480–5
Tempera on poplar, 24.8 x 21.6 cm
NG 3336

Carlo Crivelli, *La Madonna della
Rondine (The Madonna of the
Swallow)*, after 1490
Egg and oil on poplar, 150.5 x 107.3 cm
NG 724.1–NG 724.2

Agnolo Gaddi, *The Coronation of the
Virgin*, about 1380–5
Egg tempera on wood, 183.6 x 94.3 cm
NG 568

Domenico Ghirlandaio, *A Legend of
Saints Justus and Clement of Volterra*,
probably 1479
Tempera on wood, 14 x 39.4 cm
NG 2902

Giovanni dal Ponte, *The Ascension of
Saint John the Evangelist, with Saints*,
about 1420–4?
Tempera on wood, total size, excluding
the predella and pinnacles, 166.4 x
249.6 cm; predella including frame,
39.4 x 249.6 cm
NG 580.1–NG 580.12

Italian, Florentine, *God the Father*,
about 1430–40
Egg tempera on wood, 12.8 x 13.1 cm
NG 3627
Presented by Charles Ricketts and
Charles Haslewood Shannon through
The Art Fund, 1922

Italian, Tuscan, *Processional Cross*,
first half of the 15th century
Copper-gilt with champlevé enamel,
52.2 x 28 x 1.8 cm
X7370
Victoria and Albert Museum

Attributed to Jacobello del Bonomo,
The Man of Sorrows, about 1385–1400
Tempera on poplar, 48 x 30.4 cm
NG 3893

Workshop of Fra Filippo Lippi, *Female
Saint with a Flail*, mid 15th century
Tempera on panel, 48.2 x 12.1 cm
X7238
The Samuel Courtauld Trust,
The Courtauld Gallery, London

Workshop of Fra Filippo Lippi,
Saint Dominic, mid 15th century
Tempera on panel, 48.4 x 13.3 cm
X7235
The Samuel Courtauld Trust,
The Courtauld Gallery, London

Workshop of Fra Filippo Lippi,
Saint James the Less, mid 15th century
Tempera on panel, 48.2 x 13.5 cm
X7237
The Samuel Courtauld Trust,
The Courtauld Gallery, London

Workshop of Fra Filippo Lippi,
Saint Peter, mid 15th century
Tempera on panel, 48.5 x 11.5 cm
X7236
The Samuel Courtauld Trust,
The Courtauld Gallery, London

Lippo di Dalmasio, *The Madonna of
Humility*, about 1390
Tempera on canvas, 110 x 88.2 cm
NG 752

Attributed to Lorenzo Monaco,
The Baptism of Christ, 1387–8
Egg tempera on wood, 38.5 x 28.5 cm
NG 4208

Zanobi Machiavelli, *A Bishop Saint
and Saint Nicholas of Tolentino*,
probably about 1470
Tempera on wood, 143 x 59.5 cm
NG 586.2

Zanobi Machiavelli, *Saint Bartholomew and Saint Monica*, probably about 1470
Tempera on wood, 142.5 x 59.5 cm
NG 586.3

Zanobi Machiavelli, *The Virgin and Child*, probably about 1470
Tempera on wood, 163.8 x 70.5 cm
NG 586.1

Andrea Mantegna, *The Virgin and Child with the Magdalen and Saint John the Baptist*, probably 1490–1505
Tempera on canvas, 139.1 x 116.8 cm
NG 274

Margarito d'Arezzo. *The Virgin and Child enthroned, with Scenes of the Nativity and the Lives of Saints*, about 1263–4(?)
Tempera on wood, 92.1 x 183.1 cm
NG 564

Master of the Albertini (Master of the Casole Fresco), *The Virgin and Child with Six Angels*, about 1310–15(?)
Tempera on synthetic support, transferred from wood,
194.2 x 170.6 cm
NG 565

Master of the Life of the Virgin, *The Presentation in the Temple*, probably about 1460–75
Oil on oak, 83.6 x 108.6 cm
NG 706

Workshop of the Master of the Life of the Virgin, *The Mass of Saint Hubert: Right Hand Shutter*, probably 1480–5
Oil on canvas, transferred from wood, 123.2 x 83.2 cm
NG 253

Master of the Osservanza, *The Birth of the Virgin*, about 1440
Egg tempera on wood, 31.9 x 50.9 cm
NG 5114

Attributed to the Master of the Pala Sforzesca, *Saint Paul*, about 1495
Oil on walnut, 23.8 x 13.3 cm
NG 3899

Attributed to the Master of the Pala Sforzesca, *The Virgin and Child with Saints and Donors*, probably about 1490
Oil on wood, 55.9 x 48.9 cm
NG 4444

Master of the Palazzo Venezia Madonna, *Saint Mary Magdalene*, about 1350(?)
Tempera on wood, 60.1 x 34.5 cm
NG 4491

Master of Saint Giles, *The Mass of Saint Giles*, about 1500
Oil and egg on oak, 61.6 x 45.7 cm
NG 4681
Presented by The Art Fund, 1933

Neapolitan Follower of Giotto, *The Dead Christ and the Virgin*, 1330s–40s(?)
Tempera on wood, 60 x 42.3 cm
NG 3895

Niccolò di Liberatore, *Christ on the Cross, and Other Scenes*, 1487
Tempera and oil on wood, central panel including frame, 100 x 65 cm; wings including frame, each
100 x 33 cm
NG 1107

Niccolò di Pietro Gerini, *The Baptism of Christ, with Saints Peter and Paul, and Scenes from the Life of Saint John the Baptist*, 1387
Tempera on wood, 237.7 x 196.2 cm
NG 579.1–NG 579.5

Pietro Orioli, *The Nativity with Saints Altarpiece*, probably about 1485–95
Tempera on wood, 187.5 x 195.7 cm
NG 1849.1–NG 1849.2

Piero della Francesca, *Saint Michael*, completed 1469
Oil on poplar, 133 x 59.5 cm
NG 769

Ercole de' Roberti, *The Institution of the Eucharist*, probably 1490s
Egg on wood, 29.8 x 21 cm
NG 1127

Sassetta, *The Funeral of Saint Francis and Verification of the Stigmata*, 1437–44
Egg tempera on poplar, 88.4 x 53.5 cm
NG 4763

Luca Signorelli, *The Circumcision*, about 1490–1
Oil on canvas, mounted on board, transferred from wood, 258.5 x 180 cm
NG 1128

Rogier van der Weyden and workshop, *The Exhumation of Saint Hubert*, late 1430s
Oil with egg tempera on oak,
88.2 x 81.2 cm
NG 783

Marco Zoppo, *A Bishop Saint, perhaps Saint Augustine*, probably about 1468
Tempera on wood, 49.5 x 28.6 cm
NG 3541

Zanobi Strozzi, *The Annunciation*, about 1440–5
Egg tempera on wood, 104.5 x 142 cm
NG 1406

This exhibition has been made possible by the provision of insurance through the Government Indemnity Scheme. The National Gallery would like to thank the Department of Culture, Media and Sport and the Museums, Libraries and Archives Council for providing and arranging this indemnity.

ACKNOWLEDGEMENTS

This book is based on, and derived from, the research of several generations of scholars. It is impossible to do justice to their labour; neither here, nor in the footnotes and bibliography that try to pinpoint their specific contributions. Many of these same people have been indispensable in the organisation of the exhibition. I wish to express my heartfelt thanks to Joanna Cannon, Georgia Clarke, David Ekserdjian, Christa Gardner von Teuffel, Paul Hills, Amanda Lillie, Antonio Mazzotta, Susie Nash, Nicholas Penny, Patricia Rubin, Jennifer Sliwka, Luke Syson, Lucy Whittaker and Alison Wright. The previous pages draw, to the point of utter dependence, on the research of Dillian Gordon. References to all National Gallery paintings executed before 1460 are derived from her thoughtful, well-researched and exemplary catalogues, which should be read in conjunction with (and always in preference to) the current text.

To my many former colleagues at the National Gallery and the National Gallery Company, whose names are too many to be individually listed here, I am deeply grateful. Their experience and sagacity was (and is) at all times willingly shared; their patience in the face of many idiotic questions, remarkable. My new colleagues, and old friends, at the Courtauld Institute of Art have been encouraging in ways I could never have imagined, nor expected. Additionally, I would like to thank Willa Beckett, Damien Clayton, Giselle Sonnenschein and Johanna Stephenson, who have made this book possible. The debt I feel to my many other friends for their unswerving succour is better acknowledged privately.

SCOTT NETHERSOLE

PHOTOGRAPHIC CREDITS

Rock Valley College